THE COMPLETE GUIDE TO SCREENPRINTING

THE COMPLETE
GUIDE TO
SCREENPRINTING

BRAD FAINE

Foreword by Peter Blake CBE RA RDI

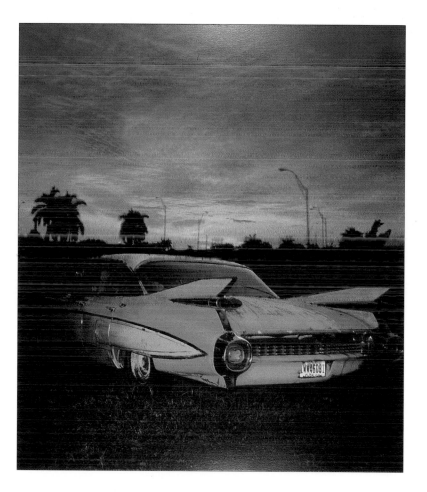

NORTH LIGHT BOOKS

Cincinnati, Ohio

A QUARTO BOOK

Copyright © Quarto Publishing plc 1989

First published in North America by
North Light Books
An imprint of F & W Publications
1507 Dana Avenue
Cincinnati, Ohio 45207

First paperback edition, 1993

ISBN 0-89134-544-2

This book was designed and produced by
Quarto Publishing plc
The Old Brewery, 6 Blundell Street, London N7 9BH

Senior Editor Cathy Meeus
Editor Patricia Seligman

Designer Anne Fisher

Picture Researcher Arlene, Bridgewater
Photographer Ian Howes

Art Director Moira Clinch
Editorial Director Carolyn King

Typeset by QV Typesetting
Manufactured in Hong Kong by
Regent Publishing Services Ltd
Printed by Leefung-Asco Printers Ltd, Hong Kong

Foreword

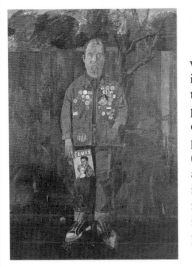

M aking a print is always the result of cooperation between artist and printer, and in my experience this is particularly true of screenprinting. I have only completed about 25 screenprints, one set of etchings (plus two or three odd ones) and one set of wood engravings. I also am currently making some wood engravings to illustrate a private press edition of *Under Milk Wood* by Dylan Thomas.

With wood-engravings you are on your own — no one else can help you cut the blocks. I taught myself to do it from books and by remembering the one or two lessons I'd had 30 years earlier as an art student. Although Cliff White of White Ink Studios printed the blocks beautifully, and Gordon helped with the graphics and folder, the main effort was mine.

I was taught to etch by Aldo Crommelynck in Paris, who is recognized as one of the best etchers in the world. Together we produced a set of nine etchings called *James Joyce in Paris.*

This couldn't have happened without Aldo's skill, and the finished prints were a joint effort.

By contrast, all the screenprints I have done have been made by a printer from an original work of mine — usually a watercolour — which I have then proofed. Although I have not literally printed my own prints, I have been extremely lucky to have worked with masters of screenprinting, and to have been involved with some of the most important events connected with the development of British screenprinting.

Chris Prater, who taught screenprinting at Hornsey School of Arts from 1958 until 1962, started a commercial studio in 1958, producing screenprinted show-cards, posters, etc. In 1961 Gordon House asked Chris if he would make screenprints for him: these must have been the first fine art screenprints of that period. Later both Eduardo Paolozzi and Richard Hamilton worked with Chris. Then in 1963 Richard Hamilton put together a portfolio of screenprints by 20 different artists for the Institute of Contemporary Arts (ICA) and I was invited to participate. I'm sure the ICA portfolio, printed by Chris Prater, changed the course of printmaking. Twenty artists made screenprints who might otherwise never have done so: some of them went on to produce a great many prints in the screenprint boom that followed. I worked with Chris Prater again when he printed my eight watercolor illustrations to *Alice Through the Looking-Glass.*

The other important event in modern screenprinting history that I was associated with was the Visual Aid print for Band Aid, which was printed by Brad Faine, the writer of this book, at his Coriander Studio in 1985. It is a beautiful and, I find, still moving, print that I am grateful and proud to have been involved with.

I treasure my association with the world of screenprinting, and with the magicians who did all the work in making prints from my paintings. This guide to screenprinting by Brad Faine is most informative, as well as being enjoyable. It has given me new perspectives into the diversity of creative possibilities of the medium and a fresh insight into the techniques used to produce some of the most effective printed images of recent years. I have learnt a great deal from it!

Maybe I should make some more screenprints — and perhaps I might even print them myself!

Peter Blake CBE RA RDI

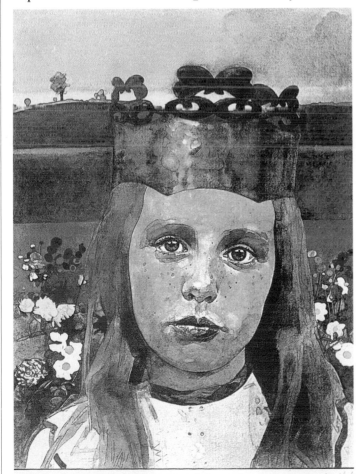

Well, this is grand!" said Alice." I never expected I should be a Queen so soon." a/p Peter Blake

Above *Self-Portrait with Badges,* 1961. Oil on board by Peter Blake.

Left *Well isn't this grand....*One of a series of eight screenprints made by Chris Prater from Peter Blake's watercolor illustrations to *Alice Through the Looking-Glass.*

Contents

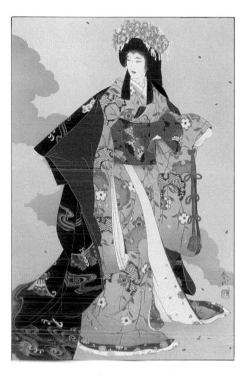

INTRODUCTION TO SCREENPRINTING

Over the centuries screenprinting has developed from its crude
early form as a method for printing crusaders' banners to its more
recent incarnation as a system of producing sophisticated fine art works.

Origins of screenprinting

The development of screenprinting in the West can be traced from two separate sources; the oldest is concerned with stencil making, while the more recent involves ink and fabric technology. The earliest evidence of the use of stencils is to be found in the Pyrenees in the Magdellenian Caves (14,000 — 9,000 BC), where negative hand prints have been found which were made by blowing pigment through a reed or bone around the outstretched fingers. In the ancient world stencils had such diverse applications as the decoration of the Egyptian tombs, the design outlines of Greek mosaics and, in classical Rome, in the lettering painted on wooden boards, publicizing attractions at the Games — an early form of advertising.

During the period of the six dynasties in China (AD 221 — 618) stencils were extensively used in the mass production of images of Buddha.

The Middle Ages witnessed an early form of screenprinting when tar was painted on stretched plain cloth and allowed to dry, forming a negative stencil. Paint was then forced with a stiff brush through the area free from tar on to banners or uniforms. The images produced tended to be simple motifs such as the crusaders' red cross.

JAPANESE INNOVATIONS

It is, however, with the import of Japanese wooden frames to the West in the mid-nineteenth century that the second and perhaps more orthodox historical development begins. The ability to attach stencils to a fixed mesh meant that intricate designs could now be accurately registered and stipple-painted with a brush. An early exponent of this technique was William Morris, who used it for screenprinting on to fabric. In 1907 the first patent was granted to Samuel Simon for a system of stencil making using filler painted directly on to the screen. This technique permitted a more finely detailed stencil. Shortly after this the squeegee was invented, enabling a more consistent deposit of ink to be printed than had been

HARUYO
Twelve Layer Kimono

This traditional Japanese image was
realized using modern screenprinting
techniques.

possible with the stippling brush. During the First World War the medium was used extensively in the production of banners and pennants.

MACHINE- VERSUS HAND-MADE STENCILS

The first photostencils of 1915 paved the way for an expansion of screenprinting into the graphic design market. Using this method, "point of sale" material that was cheap and of high quality was produced for the chain stores of the 1920s. The connoisseur approach to printing, such as etching or lithography, collapsed with the stock market crash of 1929. The depression that followed meant that artists had to produce inexpensive items for home consumption, so they turned to screenprinting, working on projects often financed by government bodies.

Hand-made prints of this period were usually made by painting directly on to the screen (gum and tusche method

see page 39). To differentiate between hand-made images and those produced by commercial printers, the artists called them "serigraphs."

"OP" TO "POP"

In the 1950s Luitpold Domberger, an entrepreneur printer/publisher in Stuttgart, offered his studio services to artists such as Joseph Albers, Willi Baumeister and Victor Vasarely. Domberger took what had been a primitive medium and refined it to produce accurately printed, highly finished works of art, later referred to as "Op Art." At the same time in the United States, Jackson Pollock and Ben Shahn experimented with the medium, but found that collectors and dealers were prejudiced against it. However, this attitude radically changed in the 1960s when Andy Warhol, Roy Lichtenstein and Robert Rauschenberg started using the medium to produce now familiar "pop" imagery.

PETER BLAKE
Babe Rainbow

Peter Blake was a founder member of the
Pop Art movement in Britain known
for his combinations of popular imagery.

EDUARDO PAOLOZZI
Bash

Paolozzi's Bash, standing for Baroque All
Style High, is typical of his early
screenprints.

KELPRA STUDIO

A parallel development was taking place in Britain with artists such as Richard Hamilton, Eduardo Paolozzi, R.B. Kitaj and Joe Tilson working with Chris Prater at the Kelpra Studio. The Institute of Contemporary Arts encouraged this experimentation by financing a portfolio of 20 screenprints by leading artists of the period, including Richard Smith, Peter Blake, and Peter Phillips as well as those already mentioned.

The 1970s heralded a technological revolution with the introduction of thin film inks and ultrafine meshes. These innovations permitted a precision in detail to be achieved as a matter of course (ie 133 half-tones). This decade also witnessed a rise in popular interest in limited edition prints and a resulting proliferation of small galleries selling such work.

The depressed economic climate of the early 1980s caused the demise of many of these galleries and halted the increase of print studios. During this period, artists and printers continued to experiment, extending the frontiers of the medium.

There is renewed hope for the screenprint artist in the late 1980s with a revival of interest in prints. This is due largely to the expansion of the market in the United States, the Far East, and the corporate market's interest in prints as an investment. This expansion has had two contradictory effects on screenprinting. First, edition sizes have increased and, second, some artists have returned to working directly on stencil making, producing small editions or even monoprints.

JOE TILSON
Sun Signatures

Enlightened by Chris Prater in 1962 to
the potential of the screenprint, Joe Tilson
went on to become one of its chief exponents.

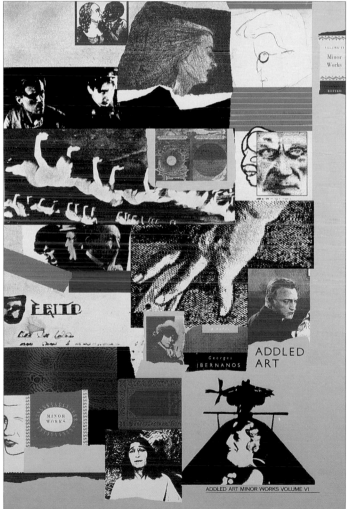

R.B. KITAJ
Addled Art Minor Works Volume VI

Also working with Chris Prater at the
Kelpra Studio, Kitaj was a prolific
producer of screenprints in the 1960s.

What is a screenprint?

Screenprinting is one of the simplest forms of print-making available to the artist. It involves the use of a stencil applied to a fabric mesh stretched over a rigid rectangular frame. Ink poured into the frame is forced with a squeegee through the open areas of the stencil. This action produces an image when the underside of the screen comes in contact with the printing material (or stock).

THE STENCIL

In order to determine what an image will look like, it is important to understand that the areas that are missing from the stencil are what will appear on the print. A stencil at its most basic may be a sheet of thin paper (ideally newsprint) with, say, a hole torn in the center of it, which is then taped to the underside of the screen. Because stencils are the means by which artists' ideas are translated into prints, it is important to understand how they work.

An easy introduction to stencil making is to be found in traditional letter form stencils. If the letter "A" is cut from a stencil it leaves a negative image that, when printed, becomes positive. Alternatively, if the surrounding area of the letter is cut away leaving a positive image, the resulting print will be negative.

The obvious drawback of stencils is that bridging pieces are necessary to prevent any "floating" pieces from falling out of the main body of the stencil — for example, the triangle in the top of the A. The problem of bridging pieces was initially solved by using human hairs to support the floating elements of the stencil. Later, silk fabrics stretched over wooden frames replaced these hair grids. But it was from the frames brought to Europe from Japan in the mid-nineteenth century that the screen for printing through was developed.

BRUCE McLEAN
Pipe Dream 1984

This three-color screenprint shows how even a simple image can have both dramatic and graphic impact.

Basic screenprinting
As an example of a basic screenprint, the letter F has been cut out of a piece of paper and fixed to the underside of the screen (1). Ink is pressed with a squeegee through the open part of the screen, that is, through the F shape (2). This prints a positive image of the letter on the sheet of paper placed beneath the screen (3).

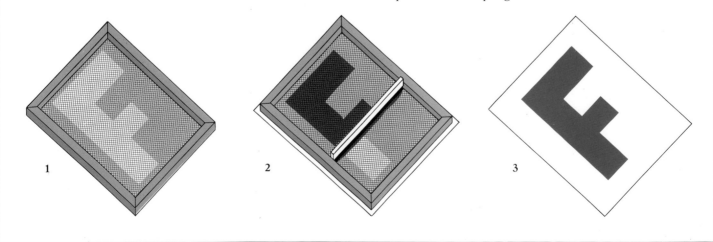

Print or reproduction?

The increase in edition sizes in recent years has led to a blurring of the difference between an original print and a reproduction. A reproduction is a facsimile of the image from which it is made — for instance, a copy of a painting printed in a book is a reproduction. Similarly, a painting or drawing printed for a poster using the four-color photographic process is a reproduction.

The criteria used by United States Customs for determining whether a print is an original (on which no duty is paid) or a reproduction (which incurs duty) are quite specific: if the colors are individually separated and printed one after the other, it is an original. If the four-color or half-tone process is used without any additional input by the artist, it is a reproduction. In Europe, the criteria are slightly more relaxed in that a print is deemed to be original if the artist intended that any preliminary work was made exclusively for subse

quent printing such as Ilana Richardson's watercolor (see page 115). Under this definition photographic processes may be used in the production of the image.

FINE ART PRINT

The fine art print can either be a work which is developed or translated from another source (a point of departure such as an artist's drawing or watercolor) or it may be created through the medium itself, in which case the artist will make a number of stencils and progressively proof them until a satisfactory print is made. In the latter case, the "original" is the finished print. Prints may be developed from concepts, photographs, drawings, experimentation on the screen itself, or simply randomly juxtaposing images. Whatever the source, printing will generate accidental discoveries, often to the benefit of the print.

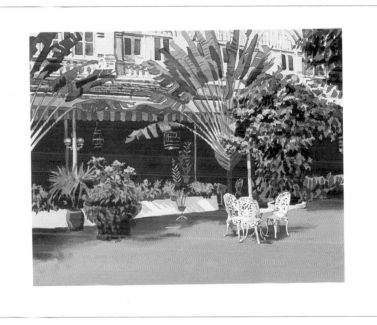

ILANA RICHARDSON
Raffles Garden 1988

This fine art print was developed from a watercolor painted by the artist. The original painting can be viewed as the point of departure and indeed the result reflects the medium used. But the range of techniques provided by the screenprinting process has allowed the artist, in collaboration with the printer, to go beyond the original concept.

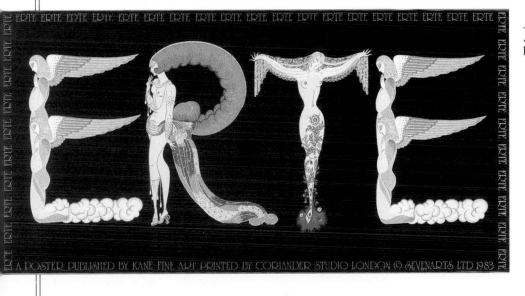

ERTÉ

An unlimited handmade poster using letter forms from the Erté alphabet.

Why make prints?

It is a good idea for artists to ask themselves why they want to make prints. For some, it is the desire to work in a new medium, others want to acquire new skills, most recognize the potential of having their work seen by a wider audience across a broader geographical spectrum. But the important point to recognize when making an edition of prints is that they are made to be sold. Few people want to reproduce an image 60, 100 or 1,000 times out of creative interest. On the other hand, it is important to realize that screenprinting is not merely a convenient reproduction process that can multiply an image prepared in some other way. For the artist-printmaker working directly with the medium it is a creative process in its own right; the challenge is to produce an image derived from the unique characteristics of that process.

The making of stencils means that the artist has to translate ideas rather than expressing them directly. If an artist paints a picture the color is applied straight onto the canvas, whereas if a similar image is printed individual stencils have to be made for each color. Far from inhibiting creativity, the practicalities of this process can provide an exciting stimulus. Technical limitations can be beneficial in that they may be turned to esthetic advantage and exploited to develop personal vision.

Creative excitement is enjoyed alike by the professional artist working with technical help and sophisticated equipment and the novice screenprinter using home-made equipment on the kitchen table. Both will gain from the stimulus of making pictorial statements in a new or different way which will inevitably feedback into their work in other media.

Working with stencils does not imply that prints must always be carefully contrived, but rather that the type of image will determine the degree of technical expertise. It may be advisable to adopt a systematic approach, to think compositionally and to analyze the print in an abstract or formal way, if that is what is required to produce a particular image, or alternatively to rely on intuition and simply print stencils as they are made, making judgments about them as each successive pull is taken. Learning to plan ahead and figure out the design as a sequence of separate operations, to make sure that maximum effect is obtained from the minimum number of stencils, may promote an intensity of creative effort that can lead to economically elegant results.

There are four options available when deciding on the size or type of editions to be printed. The **monoprint,** as its name suggests, is a unique work of art — a one-off. It may be created on the print bed as the print is being made or predetermined by juxtaposing a number of stencils. The critical factor is that it differs in its form as well as color from any other print. If a print is made using the same stencils printed in different colors this is known as a **suite**. Suites can have any number of variations, but are usually limited by exhibiting space. A variation of the suite is the **multiple**, the refinement being that each print interacts with others to produce a larger work. Finally, there is the **limited edition** where all the prints are similar to one another (see page 16). An edition is unlimited when an artist continues to produce signed prints as long as people wish to purchase them. David Hockney's well-known *Parade* poster is an example.

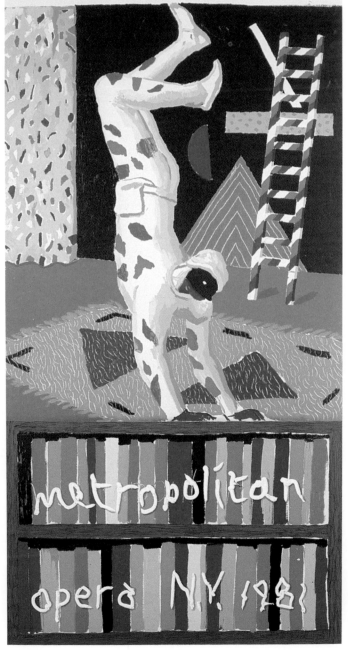

DAVID HOCKNEY
Parade

This unlimited edition print was produced from hand-separated stencils from an original painting by the artist.

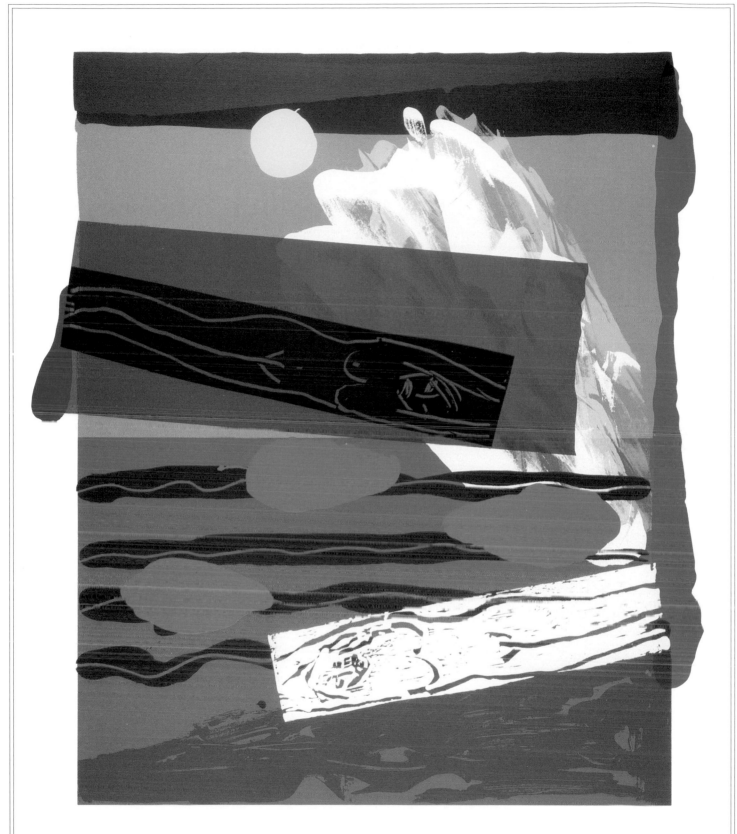

BRUCE McLEAN
Lobster Factor 10 Days 1-14

This handmade autographic screenprint is
a limited edition that was developed from
a monoprint. It was created by the artist
working closely with the printer in a
professional studio. In such a partnership
the artist produces an idea which the
printer then translates into a printed image.

Limited editions

A limited edition is a run of prints limited to a certain number with each print individually signed by the artist. The prints are signed in pencil on the border, showing that the print is of acceptable quality to the artist, and numbered in a way that proves the authenticity of the edition size — 15/125 shows that a particular print is number 15 of an edition of 125.

In the past an edition was by convention less than 100 copies. This originated from the days of purchase tax; when 99 prints were classed as "art objects," which were not liable for tax, and a 100 or more as "fancy goods," which were. The size of an edition these days can be 10, 100, 10,000 or as many as the artist cares to sign. However, there are other factors that affect edition size.

CREATING VALUE

Originally prints were limited to small editions by the technology of their production. An etching plate would deteriorate after use and consequently early or low number prints were of superior quality to later ones. Modern print technology has enabled thousands of impressions to be taken from a print without any serious deterioration in its quality. Consequently, the number of prints in an edition has no effect on the intrinsic value of that item. So, the main reason for limiting an edition is to create a value for it.

Critics of limited edition prints claim that such artificial scarcity leads to an inflated value. But since the nineteenth century, it has been common practice to create value by signing and limiting editions. The artist is always free to break with the convention of signing and numbering prints. There is a suitably unconventional precedent in the person of Maurice Escher, who produced prints from an edition as and when people wished to buy them, sometimes he signed them, sometimes he refused. Whistler, an early exponent of this practice, produced both signed and unsigned copies of the same print. Those with the signature were sold for twice the price of those without.

Printing can make images freely available, economically speaking, but the danger then is that popularity could become the only criterion for production. The limited edition, because of its potential high value, allows the work of more esoteric artists to reach their minority audience.

Collectors and dealers collaborate in artificially enhancing rarity value. As the market for contemporary art is finite and fairly small, the prints of a successful artist are often acquired for investment as "a hedge against inflation." A collector con-

TOM PHILLIPS
The Sounds in my Mind

The stencils for this limited edition
screenprint were hand-made by the artist.
The artist and maybe the publisher would
decide on the size of the edition. Here the
edition was limited to 60 which is a
medium-sized run.

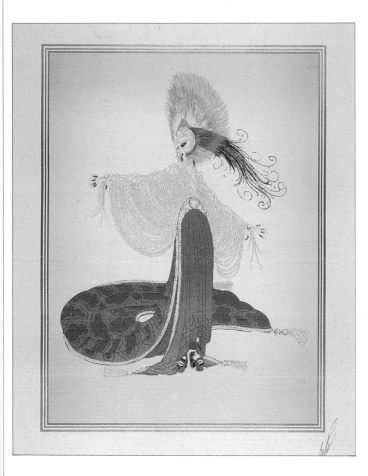

ERTE
L'Orientale

Probably one of the most prolific and
best-selling artists of screenprints, Erté
made this print in an edition of 300 with
50 proofs.

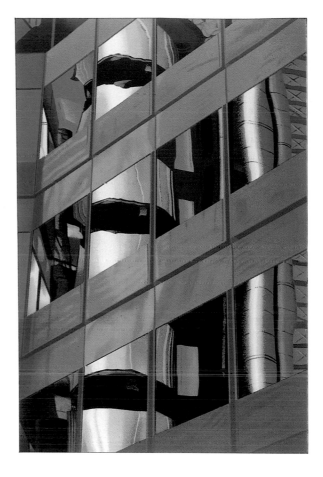

BRENDAN NEILAND
Lloyd's

This abstract view of the Lloyd's building
in London was developed from a painting
commissioned by Lloyd's.

cerned with investment will want to purchase an image which
is not widely available, in the hope that it will maintain its
value.

ECONOMICS OF PRINTING

The appeal to exclusivity, however, is not the only reason for
limiting an edition. Another equally valid point concerns the
potential market size and the economics of print production.
The unit cost of a print falls dramatically as the edition size
increases since the preliminary origination and proofing costs
are the same for an edition of ten or 100 copies. So a publisher
usually tries to print the maximum number of impressions he
is able to sell. No publisher would wish to overestimate and
thereby accumulate prints for which there is no market. But if
an edition is small, the cost of production per print will be
correspondingly high.

The retail price of a print is a function of the costs of the
artist, printer and dealer plus a notional value relating to its
investment or decorative worth (see also Selling Prints, page
134). The majority of prints are purchased for decoration,
whether by individuals or corporate bodies, so that a

publisher is unlikely to reduce the size of the potential market
merely to inflate unit value.

THE PRINT AS AN INVESTMENT

The wider use of limited editions by large companies to com-
memorate events and sponsor artistic projects has led to an
expansion of interest in prints by the corporate market. But
contemporary prints are being recognized as a good invest-
ment in a wider context — for example, a 1967 Jasper John
print was sold in 1988 for $150,000. Fortunately, this invest-
ment potential has some worthy beneficiaries. For example,
the financing of the late Norman Stevens' print for the botan-
ical cultural gardens at Kew in London by Pirelli has helped
replace some of the trees uprooted in the storm of 1987. The
Visual Aid print for Band Aid is another example. For this
print 100 separate images, each donated by the artist, were
reduced in size and printed to form a single image. This was
then reproduced in an edition of 500 with all the proceeds
going to the Band Aid Trust. It was the first time that 100 art-
ists' signatures appeared on the same print.

Other applications for screenprinting

F ine art editions are not necessarily two-dimensional or printed exclusively on paper. A large number of artists make three-dimensional prints, projecting images directly on to sculpture or paintings. For example, from 1962 Andy Warhol made numerous screenprints directly on to stretched canvas for such works as the *Marilyn Diptych* or *Green Coca-Cola Bottles*. The extension of printing into three dimensions and perhaps combined with other materials inspires many artists.

COMMERCIAL USES OF SCREENPRINTING

In the commercial world, screenprinting is found to be very versatile and is used on a wide range of surfaces from textiles, metal, wood, glass, plexiglass or plastic to cardboard, bricks, plaster, rubber and canvas — in fact, almost any surface. The screenprinting process is used in the ceramics industry for making transfers for the firing and direct screening of slips for pottery or ceramic decoration. The instant lettering used in

design studios and dry release transfers played with by children are only available because of screen ink technology. But it is in the graphics industry that it is most widely employed — on huge billboards, various aspects of advertising, information on equipment, and all sorts of decals and labels.

Printed circuits, essential to computers and household consumer durables, are screenprinted, taking advantage of the accuracy and precision possible with stainless steel meshes.

Screenprinting does not only work on smooth surfaces; walls, for example, can be decorated with images printed directly on them. Bottles and cans are printed directly on cylinder presses, plastics are often vacuum-formed after being printed with flexible ink, and decorated balloons are inflated with expanding ink images on them.

The use of the screenprint is fundamental to the textile industry whether for producing exclusive hand-printed

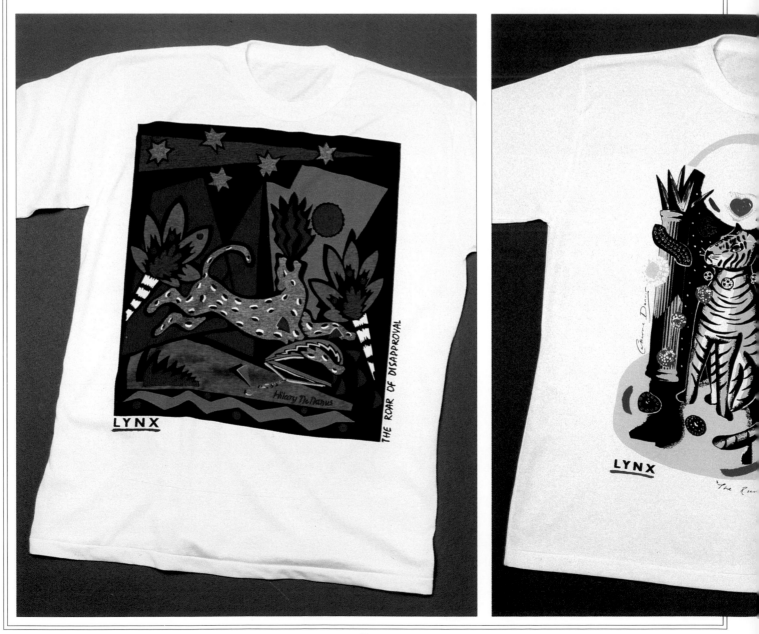

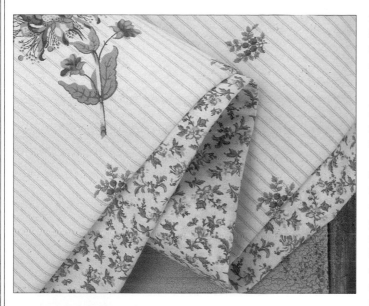

Screenprinted textiles
The textile industry uses the screen-printing process for much of its pattern printing, not only for such exclusive fabrics as this chintz from the Laura Ashley range (above), but also for mass-produced items like tee-shirts (left).

fabrics or chain store materials, tee-shirts or designer logos. Some of the more bizarre uses of the medium are to be found in the food industry, where cakes and candy are sometimes decorated by printing with egg tempera and edible dyes.

NEW DEVELOPMENTS

New developments include touch-sensitive electronic inks, rub-off inks for contests, and scratch-and-sniff inks for magazine advertisements or sensory films.

But it is the arrival of ultraviolet cured inks which has done most to open up new areas of activity. These inks remain wet until exposed to ultraviolet light, when they dry exceedingly quickly. This development has meant that high-quality book production and print runs, which were formerly appropriate only for lithographic printing, are being silk-screened, combining color quality with a comparable printing speed to that of an automatic litho press. The future of screenprinting is only as limited as the vision of those who use it, and there will always be those who find new uses for it. Unlike the other established fine print mediums, such as etching, engraving and lithography, screenprinting is still in the process of building a tradition.

LIMITATIONS OF SCREENPRINTING

The development of thin inks and fine meshes means that there are very few images which are not possible to print. Indented or embossed lines cannot be printed by screening, as the process requires pressure which is only obtained by direct printing, such as etching or engraving. Raised lines on the surface, however, can be produced using the appropriate ink and, as can be seen in Chapter 6, shapes can be embossed after printing.

The wash effect, produced by collotypes and to a lesser degree lithography, is difficult to produce in a single printing. But it can be approximated by sequential prints — the greater the number, the better the result.

The printing of continuous tone, irrespective of medium, requires for it to be broken down into small particles and printed as fine dots, either regular (in the case of half-tone) or irregular (for a mezzotint). Screenprinting can print a fine dot pattern (133 is possible), but lithography, etching and gravure can produce finer images.

Within these limitations, almost anything can be printed. The difficulty is in determining how to make the stencil and deciding what sort of mesh should be used.

Part Two

PLANNING YOUR SCREENPRINT

The basic equipment required for screenprinting is minimal and need not be expensive. What is required is a frame stretched with fabric, a squeegee, some ink and something to print on — stock, such as paper. Having assembled the equipment, you will, of course, also need to plan the image you wish to print.

The frame

The frame is the support over which fabric is stretched; together they make up the screen. At its simplest, a frame can be made from a thick cardboard rectangle with a smaller rectangle removed from the center, covered on one side with a coarse organdy fabric that has been stuck to the cardboard. This would be perfectly adequate for printing Christmas cards, or small images up to 6×8in.

WOODEN FRAMES

The most readily available type of frame and the one chosen by most beginners is a wooden one, either homemade or custom manufactured. Making the frame yourself is not difficult, but requires some basic carpentry skills. An advantage of the homemade frame is that you can choose the size you require — 16×24in is a good size to start with. The wood should have straight grain and not be warped — cedar is often used by commercial manufacturers as it is water resistant, rigid and light to handle. Make sure the weight of the wood is appropriate for the size of screen being made, as the fabric exerts a considerable tension when stretched. But the frame should not be too heavy to handle easily. The corners take the strain of the tension and should be properly glued and jointed

(not simply screwed or nailed). Finally, all wooden frames should be coated with a protecting finish that is ink and water repellent, such as polyurethane varnish or shellac mixed with denatured alcohol (French polish).

READY-MADE FRAMES

If the cost of the artist's time is taken into account, it is probably more economical to buy a ready-made frame, unless you possess an adequate tool kit and enjoy making things. The advantage of the manufactured frame over those made at home are that it will be made of the correct material, with the right ratio of cross section to frame, and with properly jointed corners (see below left).

Wooden frames can be purchased in 6in incremental sizes from 6×8in to 108×76in as standard, and any other size by negotiation. The frame should always be the largest size that is practical, since many small images can be put in a large screen, whereas obviously a large stencil will not fit into a small one. A wooden frame is easiest to work with for the printer who wishes to stretch his own meshes, as it can be tacked or glued depending on which stretching method is used (see page 24).

METAL FRAMES

Most professional printers use metal frames; they are more durable and, if correctly stretched, they make it easier to register prints correctly as they do not warp or bow under fabric tension. Wooden frames, even if they are professionally manufactured, will eventually flex and warp, causing stencils to distort.

Metal frames are made either of aluminum, which is light to handle but subject to distortion if clumsily attached to the printing table, or steel, which, if coated with baked-on preserver, is the strongest and most durable material available. There are two main cross-section profiles: the box, which is rectangular, and the seriframe (see below). If a homemade print table is being used for printing (see page 59), a box section frame is best because it is more easily attached. If a professional printing table is used, the seriframe is stronger, more resistant to fabric tension and, because of its inside profile, easier to clean.

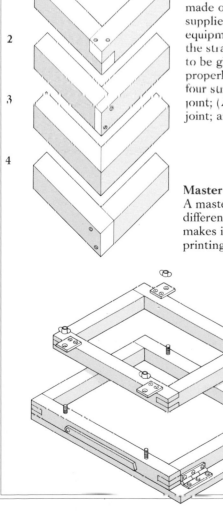

1 2 3 4

Wooden frames (left)
Wooden frames can be home-made or purchased from suppliers of printing equipment. The corners take the strain and therefore need to be glued and jointed properly. Illustrated here are four strong joints: (1) end lap joint; (2) rabbet joint, (3) miter joint; and (4) butt joint.

Master frame (below)
A master frame into which different frames can be fitted makes it easier to remove the printing frame for cleaning.

Metal frames
Metal frames are durable and are unlikely to bow under fabric tension. There are two cross-section profiles: (1) the box frame and (2) the seriframe.

Meshes and fabrics

A wide range of materials can be stretched over the frame to make the screen. What you choose depends on the job you want it to do and on how much you want to spend. Organdy, silk, nylon, mono- and multifilament polyester or metal are all commonly used. The size of the mesh of the fabric is measured in threadcount per inch. The "mesh opening" is the distance between threads, and the "open area" is the percentage of mesh openings to threads in an area of fabric.

FABRIC WEIGHT

The fabric you choose should be as strong as possible to prevent it from splitting when stretched, dimensionally stable and unaffected by moisture or humidity. The material should be inert and impervious to the chemicals to be used in contact with it. The greater the tensile strength of the fabric, the more consistently it will register, since it will resist distorting when the squeegee is pulled across it.

The weight of heavy-duty fabric for long print runs is described as "high density." For fine art and hand printing, a standard mesh is used. A high-density mesh with the same thread count as that of a standard mesh requires greater squeegee pressure during printing and deposits a thinner film of ink due to the smaller mesh openings.

MESH COUNTS AND INK DEPOSITS

The mesh count limits the open area of the mesh, which in turn determines the quality of the ink deposit. A fine mesh with a high count allows only a thin film of ink to be printed, whereas a coarse one allows a heavy film. When planning your screenprint, it is important to decide how heavily inked you want the print to be and what mesh count is appropriate for the job. Most professional studios use a range of about six different counts, but to print glitter inks, a very coarse mesh is needed.

It is sensible practice to write indelibly on any new frame what the mesh count of the fabric is. If this is forgotten, the count can be checked by using a mesh microscope to help to count the threads.

BUYING FABRICS

All fabrics are available in the roll from specialist suppliers, in widths of 40, 45, 50 and 54 inches. The minimum quantity normally sold is half a yard. The finest, most readily available fabrics are 200–250, 250–300 and 305 (which is very fine) threads per inch in a standard weight. Although they are designed for use with ultraviolet inks, such fabrics can be used for a dot matrix of fine half-tones with suitably thinned conventional inks. Fabrics are usually available in white or antihalation orange or yellow for use with direct photostencils (see Chapter 3). This coloration prevents light from scattering through the threads when the stencil is exposed to the ultraviolet source.

TYPES OF FABRIC

There are six different types of fabric suitable for making screens, each varying in character, cost and, in some cases,

suitability for different uses.

Organdy is a cotton fabric, generally with a mesh count of 70 — 90 threads per inch. Because it is the least expensive option and is easy to stretch, it is ideal for the beginner.

Organdie can be obtained from fabric stores. It is suitable for use with cardboard frames to produce small prints such as Christmas cards. The limitations of this combination will quickly become apparent to the artist: the low tensile strength of the fabric and the fact that it expands when wet and contracts when dry, makes it difficult to register. Another disadvantage of organdy is that it deteriorates rapidly because it is attacked by most of the chemicals used in screenprinting.

Silk was the original fabric used for screenprinting; it is stronger than organdy. Silk should be moistened when stretching to obtain a really taut screen. In most situations silk is inferior to synthetic materials, except for the gum and-tusche method of stenciling (see page 39). Silk should never be used with photostencils, as the bleach used in the process attacks the mesh.

Monofilament nylon fabrics are produced with finer threads or filaments than silk and are stronger and more elastic than those mentioned above. The elasticity is an advantage when printing on irregular surfaces, such as ceramics, canvas or even bricks, but a disadvantage for tight "edge to edge" or butt register printing (see page 66). If properly stretched, nylon is a good general purpose material. It should not really be stretched by hand, as it requires a two-stage process: first, it needs to be tensioned to the correct stretch and then allowed to slacken for 15 minutes. Then the

KATHERINE DOYLE
Quiet Evening

This screenprint was created using two different sizes of mesh: the variegated wash effect of the evening sky required a coarse mesh; the hand-painted areas were reproduced on a fine-meshed stencil.

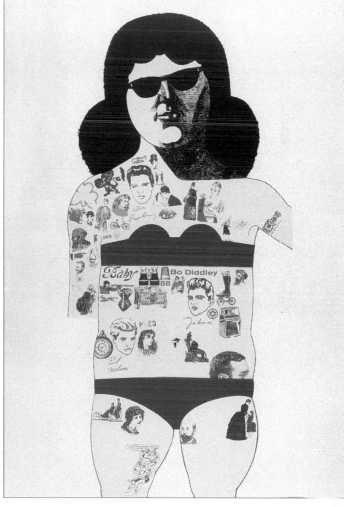

center needs to be dampened before finally completing the stretch and sticking the fabric to the frame.

Monofilament polyester is the best material to use for printing limited editions, because of the need for accurate registration. It is the strongest, the most dimensionally stable and chemically inert of all the non-metallic meshes. Like nylon, it requires two-stage machine stretching to a higher tension than most fabrics and will accept all stencil materials if properly prepared. Multifilament polyester is used extensively in the textile industry and in the printing of large posters for billboards when direct photostencils are used.

Stainless steel and nickel-plated polyester are the most dimensionally stable fabrics, producing consistently accurate registration. They are mainly used for printed-circuit or similar precision work. However, they have disadvantages for the fine art printer in that they are expensive and crease if badly handled, making them useless for any stencil application. The rigidity of these materials prevents deliberate local distortion with tape to correct registration irregularities (see page 64). Metal meshes should be stretched professionally as they are expensive and it is better that the risk of splitting while tensioning is borne by the stretcher.

PETER BLAKE
Tattooed Lady

Artists will often combine a variety of mesh sizes within a single print. Here Peter Blake reproduces the dense areas of black and blue with a coarse mesh and the intricate detail of the tattoos with a much finer mesh.

Stretching the frame

T he next step after obtaining the frame and selecting the fabric is to fix the fabric to the frame to make the screen, a procedure known as stretching the frame. For a wooden frame, the fabric can be stretched by hand, but a more professional result is obtained by using a mechanical roll-bar stretcher — an expensive piece of equipment. Metal frames have to be stretched using such a mechanical device. All frames can be stretched by a professional stretcher.

PROFESSIONAL STRETCHING

It may be preferable to have screens professionally stretched as the advantages of doing this may outweigh the increased cost. If the screen is stretched professionally, you can rely on the fabric being correctly tensioned, properly adhered to the frame, and also correctly positioned with the threads running parallel to the edges of the frame, maintaining a right-angled grid pattern. The importance of this latter consideration becomes apparent when fine detail or dot matrix stencils are applied to an irregularly stretched fabric; the resulting print will have localized moiré patterns on it. Another advantage of employing a professional stretcher is that the customer pays only for the area of fabric used, since screens are usually stretched in large numbers with little wastage. In the event of the fabric splitting due to excessive stretching, the replacement cost is borne by the company, not the customer.

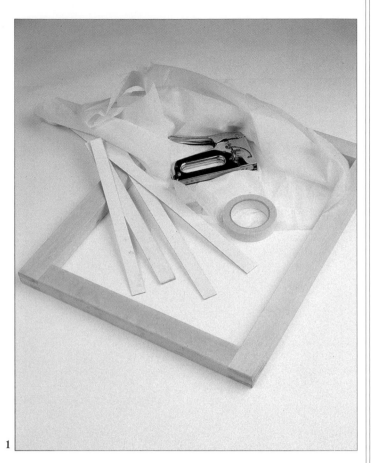

1

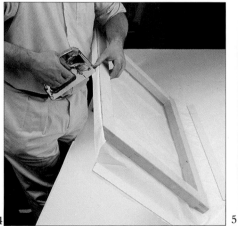

2

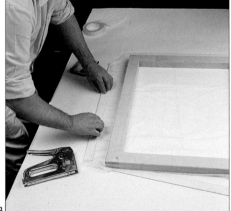

3

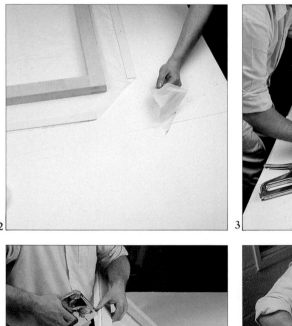

4

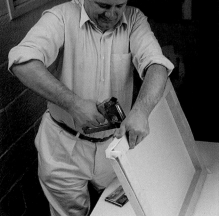

5

Stretching a frame by hand

First gather together the tools and materials you will need: the frame, mesh fabric cut to size, staple gun, strips of cardboard and masking tape or double-sided tape (1). Place the fabric on a clean flat table with the frame on top, checking that the weave is parallel to the sides of the frame. Stick the strips of cardboard with tape along the edges of the fabric to prevent the staples from tearing it under tension. Now cut the corners of the fabric (2). Beginning with one of the long sides, fold the card over so that it is sandwiched between the fabric (3). Starting from the center, staple along the frame ensuring that the fabric is stretched from the center staple (4). Pull across and staple the opposite side and then complete the other two shorter sides (5). Finally, fold and staple like a canvas.

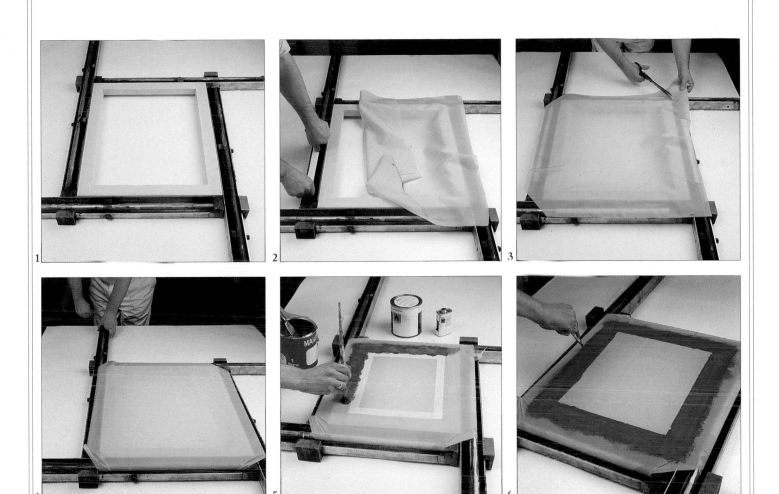

Stretching a wooden frame with a roll-bar stretcher

First the frame is placed on wooden spacers to adjust the height in the stretcher and the roll-bars adjusted to accommodate it (1). The mesh is attached to the roll-bars with double-sided or masking tape (2). Next the corners of the mesh are cut (3). The roll-bars are turned in pairs until the correct tension is achieved (4). Glue is worked through the fabric with a brush, sticking the fabric to the frame (5). Once it dries the mesh can be cut away so that the frame can be lifted out of the stretcher (6).

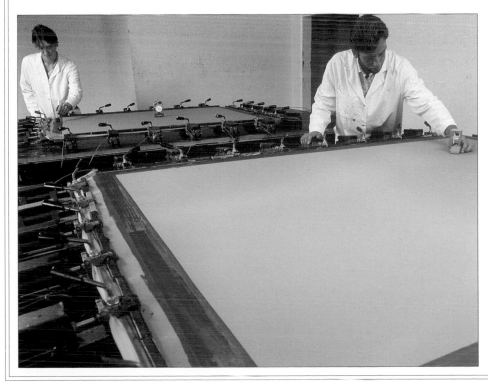

Professional stretching

Professional screen stretchers can handle large screens that would be difficult to stretch in a small studio. Here the tension of the fabric is being measured with a tension meter.

Preparing the mesh

B efore using a newly stretched mesh, it should be properly prepared or the stencils will either fail to stick to it, or they will stick only partially. The fine detail on photostencils or twin-skin cut films tends to remain on the backing sheet when it is removed after drying if a screen has been inadequately processed.

Organdy and silk should be prepared when used for the first time by scrubbing the mesh with a soft brush and a kitchen scouring powder, thoroughly rinsing off all the residue with cold water. Subsequent degreasing can be effected by washing the mesh with a 3 per cent acetic acid solution (vinegar). New nylon, polyester and steel should be prepared as described right.

RECLAIMING A SCREEN

To reclaim a screen, first all the old ink should be removed with the appropriate solvent. Next the tape and varnish must be removed. If the tape is of the cellulose type or an unvarnished gum-strip, it should be removed before proceeding to wash off any stencil material. The stencil, depending on its type, will be removed using solvent for spirit-based materials or water for soluble ones. Direct photostencil materials require specialized stencil removing agents. Indirect stencils may be removed with bleach diluted with water in the ratio of 1 part bleach to 3 parts water. Once the stencil has been attacked by the relevant chemical, it should be removed with a jet of water, preferably under high pressure. Washing should continue until all traces of the stencil and ink have been removed. With some oxidization inks, a residual image may have to be removed with "haze remover."

DEGREASING

Every time the screen is reclaimed it must be degreased on both sides. This is done by washing the mesh with either a degreasing agent or with acetic acid, which is left on the screen for a couple of minutes before being finally rinsed and dried. Household cleaners or denatured alcohol can all be used for this purpose. The specialist products for degreasing are the most efficient, but also the most expensive. Liquid agents are used rather than powder ones, which may leave a gritty deposit in the mesh and cause pin-holes to appear in any stencil applied to it. The drying time can be reduced by blotting off the excess water with newsprint and air drying with a warm hairdryer. Care should be taken to avoid touching the newly degreased mesh as even the cleanest hands have some oil on them.

TAPING THE SCREEN

To prevent ink from seeping between the edge of the frame and the mesh, it is necessary to seal this surface with tape. There are two ways of doing this. Cellulose parcel tape is quickest to apply and simplest to remove after printing. It is unaffected by ink, water or solvent. The more common and time-consuming way, however, is to use water-based gum strip which has the advantage of tightening the screen as it dries. This technique is described on the facing page.

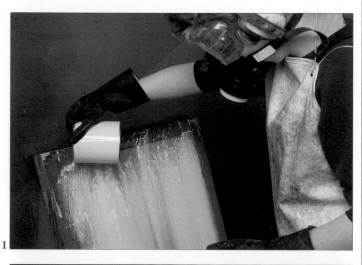

1

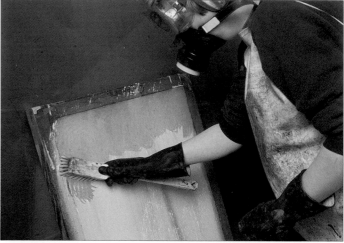

2

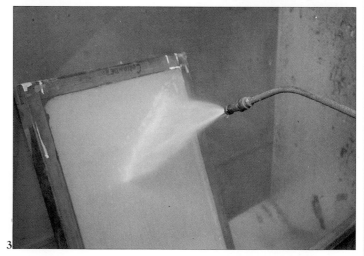

3

Preparing nylon, polyester and steel meshes
These need to be roughened to ensure that the stencil sticks to the mesh. Readymade "mesh preparation" powders or organic chemical pastes are produced by the ink manufacturers. (1) These preparations are toxic and harmful to the skin, so wear rubber gloves, goggles and a breathing mask. Apply the powder or paste to both sides of the wet mesh (2) Now scrub in the preparation with a nylon brush, before leaving it for a few minutes to react. (3) Next, rinse all trace of the preparation from the mesh.

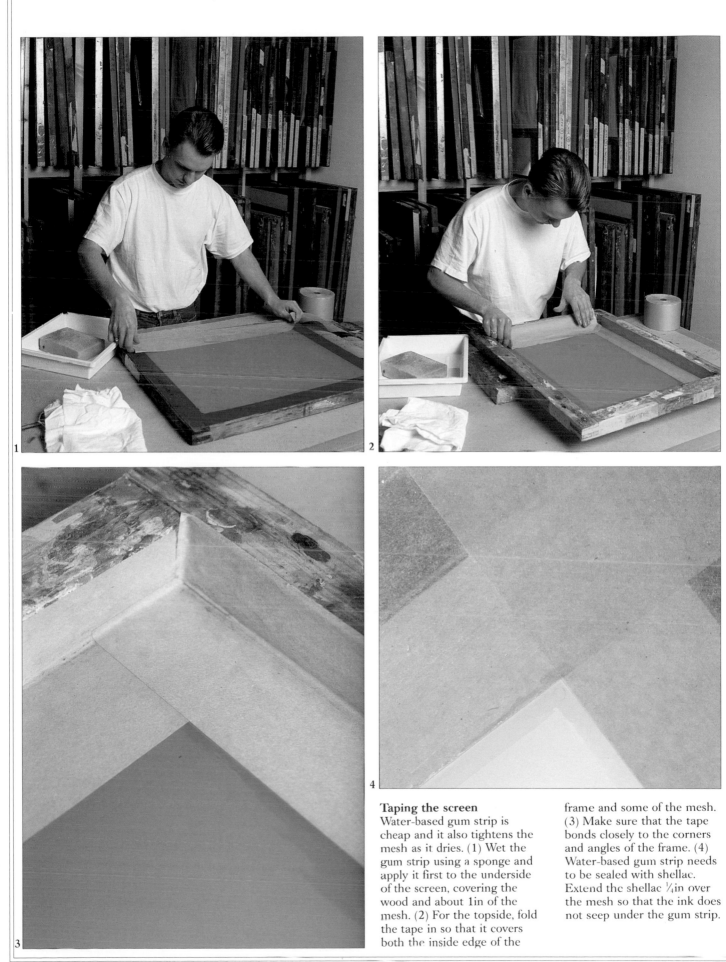

Taping the screen
Water-based gum strip is cheap and it also tightens the mesh as it dries. (1) Wet the gum strip using a sponge and apply it first to the underside of the screen, covering the wood and about 1in of the mesh. (2) For the topside, fold the tape in so that it covers both the inside edge of the frame and some of the mesh. (3) Make sure that the tape bonds closely to the corners and angles of the frame. (4) Water-based gum strip needs to be sealed with shellac. Extend the shellac $\frac{1}{4}$in over the mesh so that the ink does not seep under the gum strip.

The squeegee

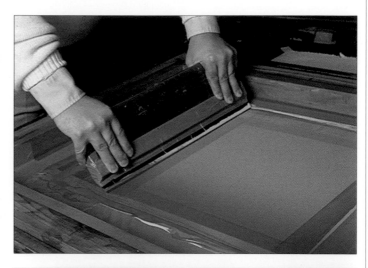

The squeegee is used to press the ink through the open areas of the mesh and on to the paper below. The most basic form of squeegee is a straight, sharply cut piece of cardboard. This is quite usable with the simple cardboard frame for a beginner to experiment with. In the studio there are three types of squeegee in common use which come in various sizes to suit the purpose: the hand squeegee, the one-arm and the composite.

The hand squeegee is made from a flexible blade inserted into a groove in a wooden handle whose profile should be comfortable when being used. The squeegee is used to cut the surface of the ink cleanly, using the minimum pressure to produce a good-quality image. It should not be used to force ink through the screen under excessive pressure.

The one-arm squeegee is attached to the back of the printing table and runs along a rail parallel to the front of it. This type of squeegee has the advantages of being easier to control than is the hand squeegee, less tiring to use when editioning, and it does not fall into the ink. Its disadvantages are that it makes blending more difficult (see page 70) and it is less sensitive to localized pressure if small areas of the stencil are proving difficult to print. Hand squeegees should not be used with one-arm units, as the extra pressure will often distort them.

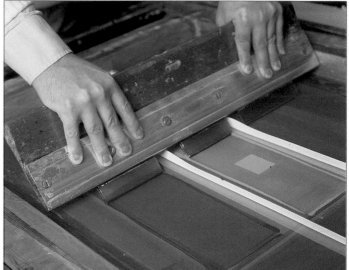

The composite squeegee can be used for either hand or one-arm unit printing, as the blade is held in metal grippers along its entire length. The composite squeegee can be taken apart for cleaning, but it is still easier to pre-tape the blade, rather than take the tool to pieces. An advantage of the composite squeegee is that it can have a number of small blades attached to it, and thereby enable you to print different colors on the same print stroke.

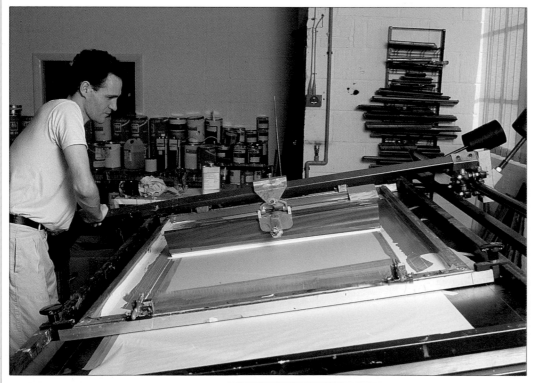

Hand squeegee (top) is a wooden handle fitted with a flexible blade, which is inserted into a groove in the handle.

Composite squeegee (above) This type of squeegee has metal grippers to hold the blade and can be fitted with a number of small blades so that several colors can be printed with the same print stroke. This squeegee can be used for both hand and one-arm printing.

One-arm squeegee (left) Attached to the back of a printing table, a one-arm squeegee runs along a rail parallel to the front of it. This squeegee takes much of the strain out of printing large editions.

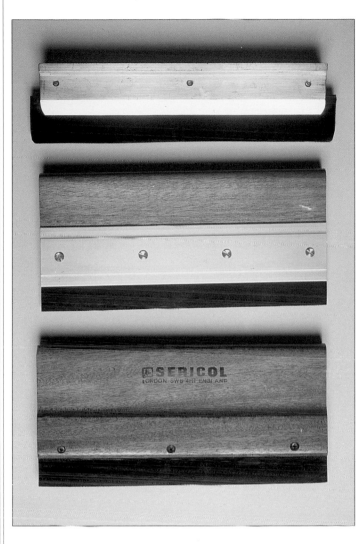

Types of blade (above)
Rubber blades need frequent sharpening; polyurethane stays sharp for longer. It is usual to fit a hand squeegee (**above**) with a soft blade. The one-arm squeegee (**top**) is likely to require a polyurethane blade. The composite squeegee (**center**) can be fitted with different blades at the same time.

Taping the blade (top)
Taping a squeegee makes it easier to clean. It also prevents the ink from seeping into the handle groove only to reappear as streaks during subsequent printing.

Sharpening the blade (above)
The squeegee blade should be kept sharp. It can be sharpened with a homemade wood and sandpaper device or with a manufacturer's squeegee dresser. A custom-made sharpening device is illustrated above.

THE BLADE

The squeegee blade is made of either rubber, which is inexpensive but becomes blunt very quickly, or polyurethane, which maintains its sharp edge for more printings. Both types of blade come in three different grades - hard, medium and soft. Hard blades are used for printing on shiny flat surfaces that are non-absorbent, such as glass, plastic or coated board, where the minimum of spreading can be tolerated. Medium flexibility squeegees are used for printing on all absorbent surfaces, where a higher pressure is used for printing, as when using a one-arm squeegee or an automatic machine. Soft blades are ideal for hand printing since they flex to accommodate undulations in the printing stock and are sensitive to fluctuations in pressure, allowing difficult areas to be printed.

Angle of squeegee
The angle at which the squeegee is held determines the thickness of the ink deposit; the more upright the blade, the thinner the deposit (**below left**); the lower the blade, the thicker the ink will print (**below right**).

Paper for printing

lthough paper is not the only stock on which limited editions or fine art prints are printed, it is the most common. Although screen inks adhere to the majority of papers and boards, it is good practice to test a new paper by printing on it and checking the ink for scuff resistance and adhesion.

As there are so many papers available, it is useful to look at the characteristics of papers in general. There are three main types of paper, handmade, mould-made, and machine-made, varying widely in price and usage.

PAPER SURFACES

The three characteristic surfaces of paper are "hot pressed and callendered" (HP), which means that the finish is smooth, "rough," meaning textured rather like watercolor paper and "cold pressed" (NOT) surfaced, which has a texture between HP and rough.

The way paper has been sized, which is part of the manufacturing process, determines its degree of absorbency. The greater the absorbency of the paper, the greater the tendency of the ink to spread, possibly blurring detail. The most absorbent is "unsized" or "waterleaf." Many screenprints, however, are made on paper that is "internally sized" because it is fairly dimensionally stable and absorbs only a small quantity of ink, thereby holding detail. Internally sized papers are reasonably crease resistant and easy to clean. If necessary, absorbency can be reduced by sealing the paper with a transparent base before applying colors.

GRAIN

The grain of the paper, determined by the direction of the fibers, also has an effect on the quality of the print. In handmade papers the fibers adopt random directions, producing a strong, light-fast paper which provides excellent color resolution. The disadvantages of handmade paper are that it is very expensive, it is usually only produced in small quantities, and each sheet varies in quality so it is not suitable for large limited editions. It does have the advantage, however, that it can be pigmented in production. Mould-made paper is similar to handmade up to the point of manufacture, where rotating cylinder machines produce a product of similar quality to that made by hand, but with a quality that is constant. Unlike handmade paper, the grain of mould-made paper has definite direction, determined by the machine on which it was made. In long-grain paper, the grain runs parallel to the long edge of the paper and in short-grain paper, the grain runs parallel to the short edge.

OTHER DISTINGUISHING FEATURES

The natural deckle is the rough finished edge of the paper. On handmade paper it is on four sides, whereas on mould-made paper it is only on the two outside machine edges. Natural deckles run parallel to the grain; imitation or torn deckles run at right angles to it.

Each sheet of paper has a top or "felt" side and a bottom or "wire" side. In the production process, papers are often "watermarked." Normally prints are printed on the felt side,

Handmade paper (above)
David Hockney experimented in the 1970s with making his own paper. *Driving Board with Still Water on Blue Paper (1978)* is one of a series of prints on paper made by adding pigment to the paper pulp and pouring it into preformed molds before pressing it. Thus the image became part of the paper itself.

with the watermark "right reading."

WEIGHT AND SIZE

The weight of the paper should be taken into account when making prints. If a sheet is large, it also needs to be heavy to enable it to be handled successfully. The weight of paper is expressed in pounds. Papers come in a huge choice of weights, but the heavier the paper, the more difficult it becomes to handle, which can cause problems, for example, when rolling prints for posting.

Paper also comes in a variety of sizes. Graphic or machine-made papers — newsprint, poster, cartridge, etc — are available from art supply dealers. When deciding on print size, it is

cartridge paper is relatively cheap, which makes it a good paper to proof on. Poster paper is thin and cheap and, as its name suggests, is mainly used for printing posters. Fine art posters, however, are usually printed on matte coated paper. There are over six hundred types of coated papers and laminates in most colors — metallic, mirror foil, textured, prismatic and high gloss. These can be used to achieve special effects.

Fine art prints can be printed on any stock or surface as long as the ink is compatible, the stencil is appropriate for the image, and the mesh is of the correct count for the ink used.

Deckled paper
The edge of the paper is said to be deckled when it has a rough finish. On hand-made paper, the deckle is on four sides; mold-made paper, on two sides.

worth taking into account that most galleries have neither the means to exhibit, store nor frame very large prints.

ACIDITY

Acidity is produced by impurities or bark in wood pulp; rag papers should be acid free. The presence of acid makes the paper brittle and causes deterioration and discoloration. The acid content of paper pulp determines the pH value, which to be acid free should be above the number 7. If prints are interleaved with tissue for storage, this should also be acid free, as acid can spread through stored prints and harm them.

CHOOSING THE RIGHT PAPER

Machine made papers are used for processing as well as printing. Newsprint is probably the most widely used paper in the print studio. It is used for making stencils, masking screens or vacuum beds, processing photostencils, drying wet screens, cleaning up after printing and checking print quality. Cartridge and coated papers have their everyday uses too;

Inks and solvents

There are as many different inks as there are surfaces on which to print them. Every ink that is manufactured is supplied with a comprehensive data sheet covering use, so it is with the general properties of inks that this section is concerned.

OIL-BASED INKS

Most fine art prints are made using oil-based inks. These are usually matte-finished, fairly scuff-resistant, and of high pigment quality. The consistency and drying time of the ink can be controlled by the type of thinner used — fast, standard or retarder. Fast and standard thinners are used when printing at speed with, for example, a semi-automatic printing machine, requiring a correspondingly short drying time to facilitate the use of a tunnel dryer. For hand-printing, a retarding thinner allows a slower rate of printing and time to check each print without the ink drying into the mesh.

The consistency of the ink relates to the mesh count. For an average mesh (62, 77, 90), the ink should resemble engine oil; if the count is lower, it should be slightly thicker, like molasses, and if it is higher than the average it should be thinned to the consistency of light cream.

FINISHES

It is possible to overprint oil-based matte colors with glossy or silk varnishes to produce different surface qualities. But silk- and medium-gloss finishes are usually obtained by using solvent-based or cellulose inks. For a really glossy effect, an oxi-

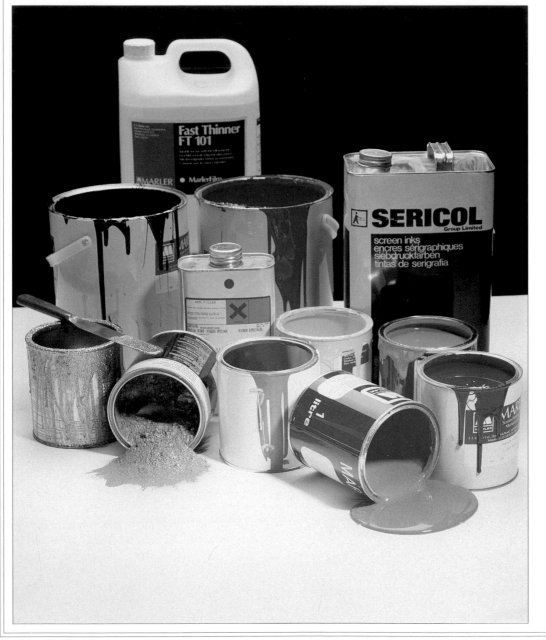

Inks and solvents
A glimpse of the range of hues and textures (note the gold glitter ink on the left) is seen here. Indeed there are many brands and types of inks used for different styles of printing and for a wide range of effects.

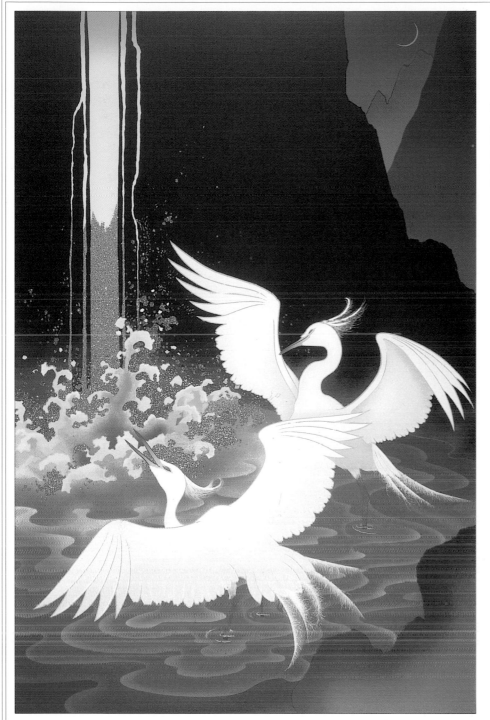

**YURIKO
Cranes**

This contemporary Japanese print based on traditional imagery uses modern glitter inks to express the reflective quality and movement of the splash of water. Today there is a wide range of inks to help the artist achieve the precise effect required.

dization ink or varnish should be used, bearing in mind that they dry by chemical reaction, which requires 24 hours in the rack, and they cannot be dried in a tunnel dryer.

When mixing and overprinting with different types of inks, it is wise to test for compatibility before editioning. Sometimes an ink designed for one paper works well for another. Matte vinyl ink, designed for printing on plastics, produces a far greater matte quality when printed on paper than any other ink, so it is a good idea to experiment.

If transparent inks or varnishes are to be tinted, this should be done using universal tinters, or trichromatic colors, as they are transparent. Tinters can also be used to boost color quality as they are high-density pigments.

Metallic powders may be added to varnishes to produce silver, gold and bronze — in fact, almost any mineral powder will work with these bases. To obtain a pencil line, add pow-

dered graphite to a metallic base. There are a number of special effect inks on the market; these include pearlized, expanding and glitter inks.

WATER-BASED INKS

Water-based inks, as used in schools, have an inherent disadvantage in that when printed on paper, the stock changes dimension by absorbing the water. However, concern with our environment and proposed future legislation in the United States will inevitably force ink manufacturers to develop new products that will solve these problems.

The advantages of water-based inks are that they are easily diluted with water and are much less trouble to clean up than the oil-based inks as they dissolve in water. If water-based inks are used, then care should be taken to select the appropriate stencil material (see page 40).

Planning the image

There are numerous ways of approaching the making of a screenprint. But for the inexperienced printer it may be useful to try one or two of the most common methods. The first is to rough out an idea as a drawing or as a series of preliminary sketches, and to develop this into an image that can be printed. It is important to always think in terms of the medium, in that each color has to have an individual stencil and that unless the color has been blended (see page 70) it is always flat, rather like gouache. The sketches should take this into account, since as soon as two or more colors are used, the question as to how to register occurs (see page 64). Generally speaking, the problems of registering colors can be minimized by conscious design decisions made at this time, for example, unsightly overlaps which may be caused by poor registration can be increased in size, and if printed with transparent color be integrated into the print design. By using transparent inks, the tone and color range of the print can be extended and the number of stencils reduced. Once a sketch has been made this should be turned into a full-size line drawing, from which the areas of each color may be selected. The parameters of these colors determine the form the stencils will take and the position or size of the overprints.

The second approach is more open to chance and consequently can be more exciting and adventurous. Printing commences with a first stencil which is made intuitively and printed with a color selected by personal taste. Subsequent stencils and the colors in which they are printed are improvized according to the critical judgement or whim of the artist, each stage suggesting further developments. This approach can be used to print both limited editions and monoprints.

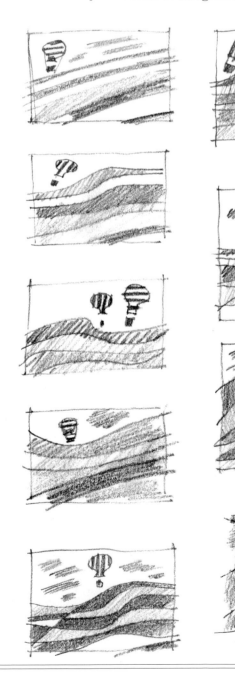

Exploring the idea

The artist Raymond Spurrier, whose print is featured on these pages, said: "After the initial inspiration found while driving through the countryside in late summer, I set about trying to devise an image which could be realized using simple hand-printing equipment with registration managed entirely by eye.

I tried out various compositional options with thumbnail sketches (**left**). The placing of adjacent colors would demand meticulous stencil cutting and a degree of registration accuracy that seemed unlikely in the circumstances. This meant that it was necessary to make a design that took advantage of overlapping color so the image was further abstracted into broader areas of color."

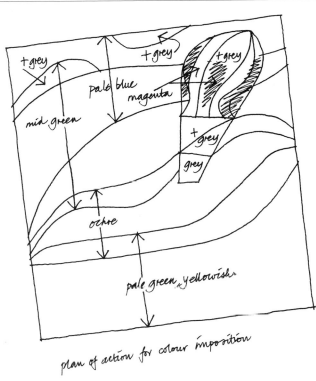

plan of action for colour imposition

Finalizing the image

Once a suitable composition had emerged, the artist made a larger outline drawing (left) to help plan the colors and the most effective way of overlapping them. This drawing shows how he printed seven colored stripes for the landscape using only four transparent ink colors: blue, light green, dark green and ocher. It also became clear to him that he would need only two stencils for the four colors — the blue and ocher were well separated and could therefore be cut from the same stencil with the ocher temporarily masked out while printing the blue and vice versa. The two greens were printed similarly The balloon was printed in magenta to isolate it from the landscape, and the stripes overprinted in pale gray which is used elsewhere. The final print, *Late Summer Balloon,* is shown below.

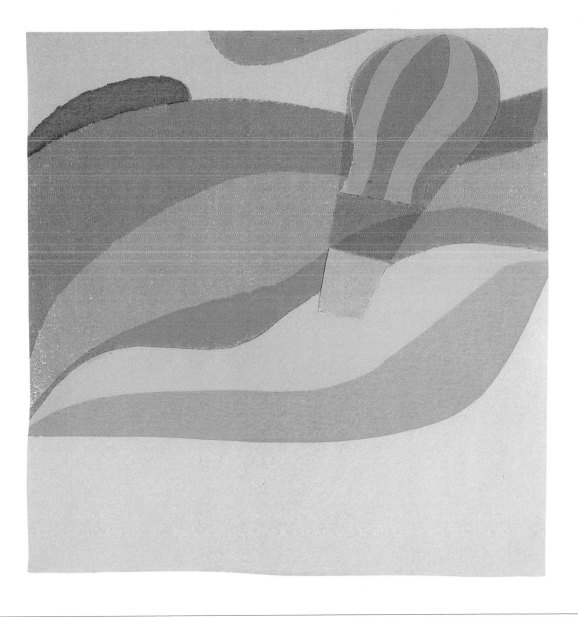

THE ART OF STENCIL MAKING

The stencil is the medium by which an idea, drawing, painting, photograph or existing original image may be interpreted, translated into a form which will print, and then be creatively developed.

There are three principal groups of stencils — "handmade," which are directly applied to the screen, "autographic" and "photographic." The last two have to be processed before being attached to the screen.

Cut or torn paper stencils

Paper stencils are the simplest to make and use. They can be made from thin paper such as newsprint, detail paper or parchment paper, and they are stuck to the underside of the screen with printing ink or tape. A hole torn or cut in the center of a sheet of newsprint attached in this way produces a positive printed image. Negative images can be produced by placing pieces of cut or torn paper on to the printing stock, lowering the screen and sticking them to the mesh using the squeegee and printing ink. More complicated designs with "floating" pieces of stencil should be stuck to the screen with filler or ink, which is allowed to dry before printing the image. Everyday objects such as doilies or open-weave fabrics or even cut-out strips of little paper dolls make good stencils.

One of the problems of paper stencils is that they tend to disintegrate fairly quickly. But it is possible to produce quite large editions as long as the ink is not too thin (about the consistency of engine oil) and the squeegee blade is soft. Paper stencils should not be used with coarse screens as the ink will tend to bleed, or on those that are too fine to allow the ink to penetrate enough to stick the paper to the screen. Any mesh count between 42T and 90T is suitable.

Torn-paper print (above) The simplest form of print-making, here a square has been torn out of a piece of newsprint which has then been taped to the underside of the mesh. The figure and four symbols are floating pieces stuck to the mesh with the printing ink.

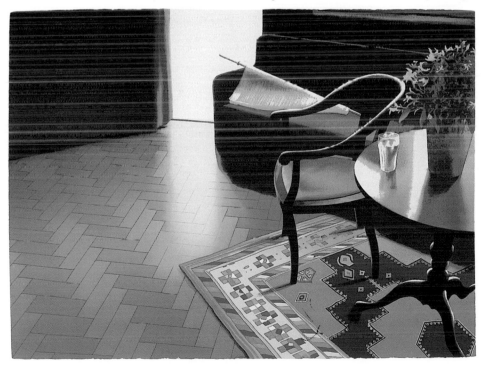

MICHAEL POTTER
Garden Room

In contrast to the simple stencil above, this sophisticated print involved photostencil work as well as overprinted color achieved with handmade stencils.

Stencils made with filler

S tencils have been painted on to the screen using filler since the end of the last century. It is probably the most common form of stencil-making.

Stencils made with filler usually require the artist to work negatively, that is, if a brush mark is painted on to the screen, it will appear as a negative when printed. To make the process easier, the design can be outlined on the mesh with a soft pencil to determine the areas which will need to be painted. Sharp edges or lines can be masked off using tape, and filler applied with a small piece of cardboard. Fillers are usually either water soluble (for use with oil- or solvent-based inks) or spirit based (for use with water-based inks).

RED, GREEN AND BLUE FILLERS

There are three types of water-soluble filler. Red flash-dry filler, as its name suggests, dries instantly. Its main uses are for pre-masking and edge-filling stencils made of other mat-

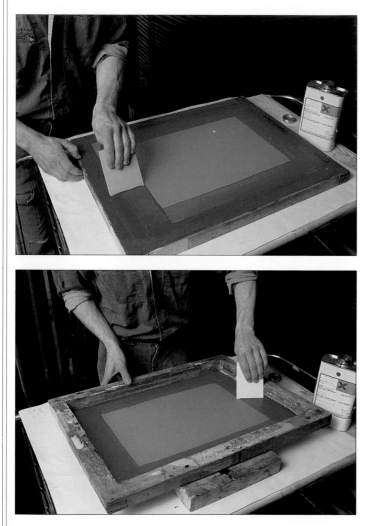

erials, and for repairing or spot-filling leaks in stencils while the print is being printed. Green filler is a moderately fast-drying fluid, which has a high viscosity and elasticity that makes it ideal for masking, painting or retouching stencils and spot-filling stencils before starting to print. Blue filler is the most useful material for making handmade stencils: it dries slowly and can be thinned extensively to enable it to be used for painting, spraying, and stippling on screens.

Water-soluble fillers can be thinned with water. A few drops of dishwashing liquid can be added to help the filler flow more easily. Drying time can be reduced, if necessary, by adding 5-10 per cent denatured alcohol to the water.

If water-based inks are to be used, filler made from a mixture of shellac flakes and denatured alcohol (French polish) should be used. This filler, though more difficult to remove when dry than its water-soluble equivalent, is suitable for fine brushwork and dries very quickly.

Whatever kind of filler you choose, it is important to match the thickness of filler to the mesh of the screen. The thinner the filler, the finer the mesh required; very coarse meshes may not be suitable for filler stencils as there is a risk that the resulting images will "saw tooth." In some cases, it may be preferable to apply several thin coats of filler rather than a single thick coat.

Filler stencils can be applied with brushes, cardboard squeegees, sponges or fabrics to produce textures. Spray guns (which produce negative dots) can be loaded with thinned filler and sprayed on to the screen. Contact prints may be taken from any surface which has previously been coated using a roller with the filler. Whatever method of production is used, it should be on a mesh that is capable of retaining the detail of the mark made; it would be inappropriate, for example, to spray dots on a very coarse screen. Mesh counts for filler screens range from 48T to 150T.

CELLULOSE FILLER

Cellulose filler is another type of filler which can be exceptionally useful when changes need to be made in existing stencils. Because it is neither oil- nor water-soluble it can be used to change or re-work stencils made from other materials, which are then printed. When the image has been printed the filler can be removed using cellulose cleaner and the stencil returned to its original state. Another use for cellulose filler is when a reverse image of the stencil is required. Use a water-solvent stencil to print the design, then apply cellulose filler to the stencil with a squeegee and allow it to dry. Finally the original stencil is removed with water, leaving a new reversed stencil in its place.

FRENCH CHALK RESIST

French chalk resist stencils are a means of creating textures on existing screen images. The procedure is to sprinkle french chalk, usually through a sieve, on to the print itself. This can either be done randomly or it can be sprinkled through cut-out shapes. The screen is carefully lowered on to the chalk and ink is squeegeed across the mesh, picking up the chalk, which produces a negative image with a textured surface.

Making a stencil edge with red filler
First, rule a line on the mesh with a soft pencil to show the area that needs covering. Apply filler first to the underside of the screen starting at the corner closest to you using a card sqeegee to spread the filler parallel to the frame (**top**). After two minutes to allow the filler to dry, invert the screen and treat it in the same way. Prop the frame to stop the underside sticking to the table (**above**).

Gum and tusche method

The gum and tusche method of stencil-making has always been popular as it enables the artist to work with a positive image — ie, whatever marks are made on the screen will eventually print.

As any printer who has tried this method knows, it is very difficult to make it work satisfactorily, but this is mainly due to the fact that modern meshes have smooth threads and the proprietary fillers do not easily break down cleanly when the tusche is dissolved. Silk is better for this method than nylon or polyester as its filaments are hairy and irregular. If silk is not available, multifilament meshes work better than monofilament ones, the counts being in the range of 48T to 90T. The traditional materials for this method are tusche (a waxy black litho ink) and gum arabic glue. Alternatively, screenprinting ink (instead of tusche) and blue filler thinned with 5 per cent acetic acid (instead of gum arabic), can be used.

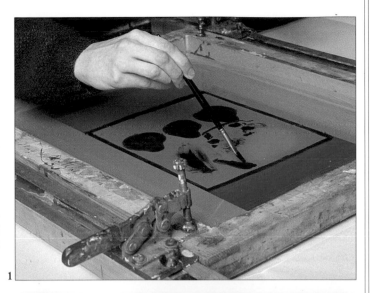

1

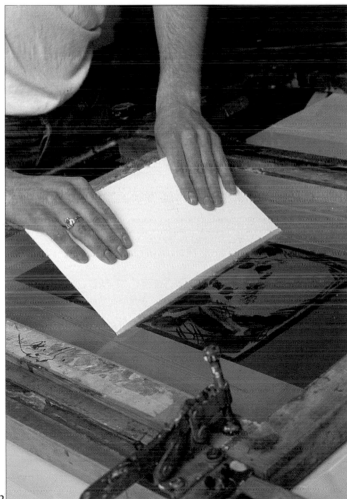

2

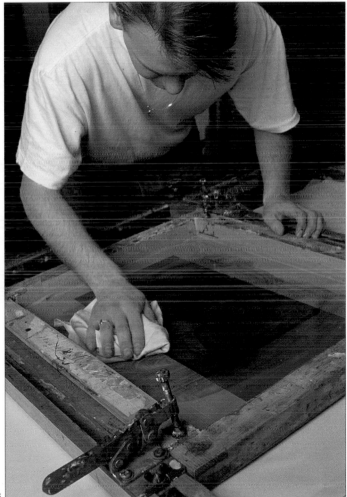

3

Gum and tusche method
This method of printing uses tusche, a black waxy litho ink, which is painted on to the top side of the screen. (1) Using whatever applicator is desired — here a brush, but a sponge or rag could be used — the image is created with the tusche on the fine silk screen and left to dry. (2) Now, from the top side, traditional gum arabic glue is spread over the mesh and allowed to dry. (3) Using a cloth, turpentine is rubbed into both sides of the mesh, dissolving the tusche and the filler covering it. This means the areas formerly covered with tusche are now open, so that the ink can pass through.

Knife-cut stencils

The stencils are cut from sheets of adhesive film which have a removable backing sheet. This method solves the problem of "floating" pieces as the backing sheet keeps them in place until they have been adhered to the mesh. This type of stencil can be fixed to screens as coarse as 16T (for printing glitter inks) or as fine as 180T. There are four types of direct adhesion films that are suitable for making knife-cut film stencils. Of these two are iron-on, one is solvent-based and the other water-based.

Iron-on stencil films, often called stenplex stencils, are the least expensive but the most difficult to bond to the mesh. Stenplex green is a film that can be used with all types of solvent-based inks on all kinds of fabric. Stenplex amber (or profilm) is suitable only for oil-based inks or, if runs are very short, water-based inks. This type of film bonds best to multifilament meshes such as organdy and silk.

Solvent-based stencil films are used with oil-based or water-based inks. Water-based stencil films are used with solvent- and oil-based inks, but not water-based inks.

CUTTING THE FILM

All knife-cut films are similar in that they have a stencil layer of material laminated on to a supporting backing sheet. There are two different stencil qualities available: high tack, which can be corrected if mistakes are made, and low tack which is easier to peel but cannot be replaced if incorrectly peeled.

The image is made by cutting through the top layer and removing those areas which are to be printed. Care should be taken not to cut through the backing sheet, as this may distort the stencil when it is stuck to the screen, or even prevent it from sticking properly. The key to cutting this sort of stencil film is a sharp knife blade. If it is really sharp, the weight of the cutting tool should be enough to cut the first layer of film and leave the backing sheet intact. Medical scalpels are particularly sharp and can be useful, but care should be taken when changing blades, disposing of used ones and in the general handling of the instrument.

Once the stencil is ready, it has to be bonded to the underside of the mesh as described on the facing page. But before this can be done, the mesh should be prepared in accordance with the manufacturer's instructions (see page 26) and all traces of grease removed.

Knife-cut masking films, though similar to stencil films, are in fact the opposite when their function is analyzed. Masking film should be thought of as a photopositive, in which whatever remains on the backing sheet after cutting is what will later appear on the photostencil.

Cutting the film
Straight lines and shallow curves are more easily cut with a fixed blade knife held at a low angle (**below left**). For difficult tight curves or fine details, a swivel knife held vertically may be easier to use with practice (**below right**). If cutting angles, overcut slightly to make it easier to peel away the film.

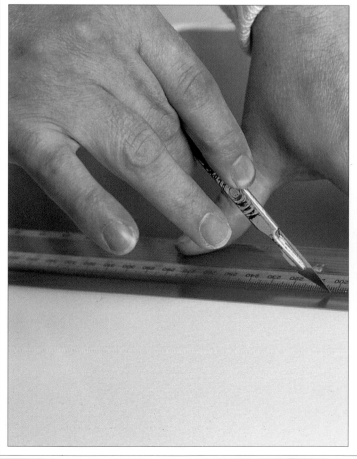

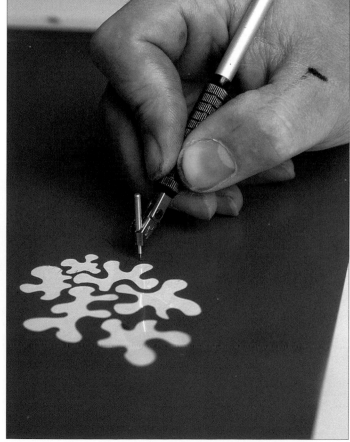

APPLYING A KNIFE-CUT STENCIL TO THE MESH

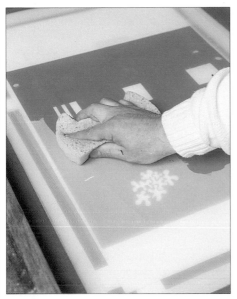 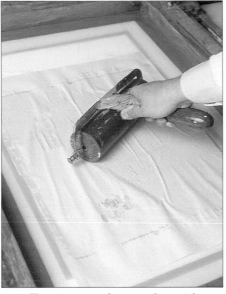 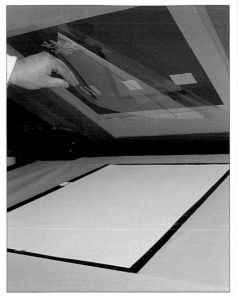

1 The stencil is placed cut surface up on a thin raised pad, smaller than the inside dimensions of the screen, which is positioned over them. To soften the stencil material so that it sticks to the mesh — here a water-based film — water is applied with a cellulose sponge. Too much water may cause the edges of the stencil to spread.

2 To encourage the stencil to stick to the mesh, cover the top side with a sheet of paper (newsprint is ideal) and roll it with a soft rubber or gelatine roller. This will encourage the paper to absorb excess moisture and force the mesh into the body of the stencil material. Take care not to apply too much pressure with the roller or the stencil will spread and the open areas close up.

3 When the stencil is quite dry (it can be force dried using a warm hairdryer placed about a yard from the inside of the screen), the transparent backing sheet can be peeled off.

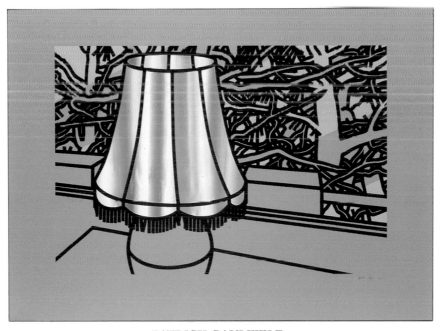

PATRICK CAULFIELD
Lamp and Pines

This print contains black photographic line work under which each color was printed through a knife-cut stencil. The lamp shade was printed with ink mixed on the open screen, making each print in the edition slightly different.

Photostencils

The photostencil freed the screenprint from its early coarseness and enabled prints of great detail to be printed hundreds of times without serious deterioration of the image. Anything which can be made acceptably opaque can be used as a positive and made into a stencil that can be printed.

Before discussing photostencils in detail, it may be useful to differentiate between the terms positive, photopositive, autographic positive and photostencil.

A positive is any image, usually on a transparent or translucent base, that is opaque enough to prevent ultraviolet light from reaching photostencil material when it is placed in contact with it. Examples of materials used to make positives include black paint or photographic opaque on tracing film, red litho tape or masking film on a transparent base, amber cut stencil film, a sheet of Letraset, torn black paper, soft black crayon on tissue paper, any opaque object and any high contrast photographs or photocopies which are on transparent film as opposed to paper. It may be slightly confusing to learn that a positive is always positive, even when the image is negative. This is because whatever constitutes the opaque element of a positive is what will eventually print.

Photopositives (as photographic positives are known) are generated in the darkroom by enlarging existing negatives or transparencies, or by photographing original artworks on to film.

Autographic positives are drawn, painted, sprayed, collaged, frottaged or otherwise handmade with an opaque medium on transparent or translucent material.

Photostencils are the means by which all of these types of positive can be made into printable images. This is done by placing the positive in direct contact (preferably in a vacuum frame) with photostencil material and exposing both to ultraviolet light through the back of the positive. The resulting stencil is then applied to the screen. As for other types of stencil, the screen has to be selected for mesh count and prepared before a photostencil can be applied to it. The photostencil has to be dried, masked, and spotted before being printed.

Positives

These positives were made in a number of ways. Opaque black ink was painted on to transparent film with a small brush (1) and a larger brush (2). A photostrip positive was used which allowed the artist to strip off certain areas and handspray them (3). A soft crayon was used on textured film (4). Hand-sprayed red masking film (5). This photostrip positive was progressively stripped off for further working (6). A photographically produced half-tone positive (7).

Methods and materials for photostencils

here are four types of photostencil material for making screenprint stencils: direct, indirect, capillary, and direct/indirect.

DIRECT PHOTOSTENCILS

Direct stencils are the least expensive of the photostencils and are relatively easy to process. They must be used if water-based or textile inks are required. Direct stencils are made with ultraviolet-light-sensitive emulsion which is applied to the whole screen and allowed to dry under light-safe conditions. A positive is then placed in contact with the underside of the screen and held tightly against the emulsion by a copy sac, a graphoscreen or a printer frame and is exposed to ultraviolet light.

The positive should always be correctly placed in relation to the emulsion on the screen. A photopositive is usually placed emulsion to emulsion. Painted or drawn stencils have the worked surface against the emulsion. The emulsion is chemically altered only where the light passes through the positive. It remains water soluble where it has been masked by the opaque parts of the positive. The still soluble emulsion is then removed by rinsing with hot water and leaves a stencil that, when dried, masked and spotted, can be printed.

If professional equipment is unavailable, small-scale direct stencils can be made in the same way by applying the emulsion, but then using a sheet of $\frac{3}{8}$in float glass and a flexible pad over which the frame fits, to support the mesh and positive. The weight of the glass holds the positive in position. The light source could either be a photoflood (see facing page), an ultraviolet lamp, or even the sun. Exposure times are a matter for experiment, but the noon sun should take about 10 minutes.

INDIRECT PHOTOSTENCILS

Indirect photostencil film comes in the form of a roll of light-sensitive film, supported on a transparent backing sheet. The

Photostencil materials
There is a wide range of photostencil materials suited to all types of printing methods. Some are designed to bond well or to stand up to long print runs, while others are particularly well-suited to fine line or half-tone work.

process for making an indirect photostencil is similar to that for a direct photostencil except that it is made away from the screen and attached to it after it has been developed. For indirect photostencils the positive is positioned so that the emulsion side is touching the backing side of the film. The positive and film are placed in the printer frame so that the light from the exposure source passes through the back of the positive and through the back of the stencil film to activate the emulsion. The opaque areas of the positive prevent light from activating the emulsion of the stencil film. Those areas exposed to light do not wash out when the film is processed.

The method of processing depends on film type. Some films need to be developed for one minute in hydrogen peroxide (20 vol) which further hardens those areas exposed to the light. Then the film is rinsed with hot water until the areas of emulsion that were covered by the positive have been thoroughly removed. The film is given a final rinse with cold water to remove any residual stencil material and to return the stencil to its pre-heated size. It is important to ensure that all the unexposed emulsion is washed away before the stencil is applied to the screen because, if this is inadequately done, the residue will dry into the mesh and form a scum in the fabric that will prevent the ink from passing through the mesh.

CAPILLARY FILM

This is also used for the indirect method and comes on a roll. A piece larger than the positive is cut and placed on a raised pad emulsion side up. The screen, ink side up, is placed over it and the film is made wet from the inside of the screen with a sponge, which draws the stencil on to the mesh. Any excess water is squeegeed off and the screen is dried under light-safe conditions (amber).

The capillary stencil provides accurate registration and it is very sensitive to detail. It also has the advantage over all indirect films in that it can be cut to the required size. Extra thick deposits of ink can be achieved with the capillary stencil by applying an emulsion coat to the printing side of the screen after the sheet film has dried. Once dry, capillary film is exposed and processed like a direct film.

DIRECT/INDIRECT PHOTOSTENCIL

The direct/indirect stencil film is bonded to the mesh with photostencil emulsion, which is applied with a soft, rounded squeegee to the ink side of the screen. The method of application — using a raised pad, light-safe drying and the subsequent exposure — is the same as for the capillary film.

WHICH FILM TO USE

All photostencil films have advantages and disadvantages so it is important to experiment to find out which is the most suitable for any individual printmaker. The indirect film is the most consistent in quality and has the ability to produce fine detail. It has the added advantage that it is ready for exposure and does not require elaborate equipment, as only the stencil is exposed and washed out, rather than the screen. Indirect stencils are also easier to remove from the screen when printing has been completed.

Light source
The type of light source used to expose the stencil film will affect the eventual quality of the stencil. A point source from one lamp will produce a better result than a number of sources. For example, Actinic blue tubes in textile exposure frames produce an inferior stencil to a halide lamp.

The best source is the metal halide lamp which is available in 2 and 5 Kilowatt models. (The latter can be switched to 2 Kilowatt for use with materials such as daylight film.) However, a fairly efficient homemade light source can be made using a photoflood. But make sure it is correctly wired using the manufacturer's recommended components.

Place the light source above the vacuum frame at a distance equal to the diagonal of the largest stencil.

Care should be taken to replace the burned-out bulbs in any light source as deterioration leads to pinholes in stencil materials.

Using either a pre-processed screen or a piece of photostencil film, exposures can be made using sunlight as a light source. Invert the screen on a raised pad and place the positive on the screen, covered with a sheet of glass to hold the positive in contact with the screen. Exposure time can be as long as an hour but you will need to experiment.

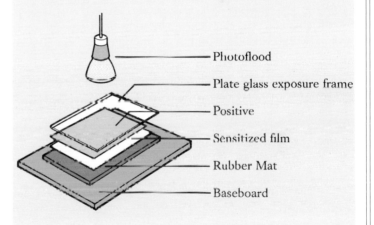

- Photoflood
- Plate glass exposure frame
- Positive
- Sensitized film
- Rubber Mat
- Baseboard

MAKING AN INDIRECT PHOTOSTENCIL

1 To make an indirect photostencil, the roll of light-sensitive film, supported on a transparent backing sheet, is cut to the right size, allowing at least 2in extra around the positive.

2 Now the film is placed in the printing frame on top of the positive with the backing side down on the emulsion side of the positive.

3 Here the printing frame is being released into the vertical position prior to exposure. The vacuum has now been switched on to hold the two films hard against each other to prevent the light scattering.

5 The film is rinsed with hot water until the areas of emulsion that were covered by the opaque positive and therefore not affected by the light have been thoroughly removed. A final rinse with cold water returns the film to its original size and washes out any residual stencil material.

6 Having checked that all particles of the unexposed emulsion have been rinsed from the stencil, it is carefully positioned on the underside of the screen.

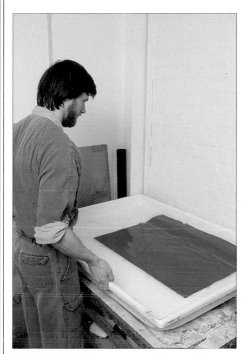

4 After exposure, some films at this stage need to be processed for one minute in a bath of hydrogen peroxide (20 vol). This further hardens those areas of the film exposed to the light.

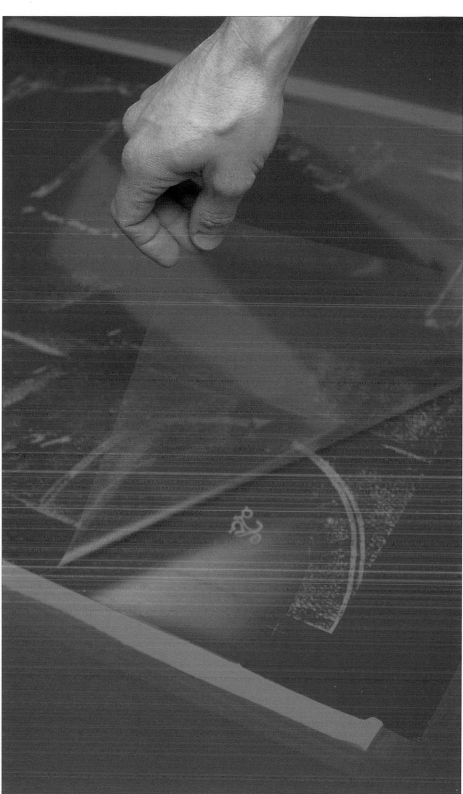

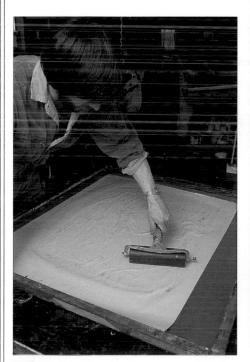

7 The stencil is bonded to the screen by laying a sheet of newsprint over it and rolling it gently but firmly with a roller to squeeze out the moisture and force the softened stencil into the mesh.

8 Drying can be assisted by a warm hairdryer from the printing side. Once dry, the transparent backing sheet can be removed from the stencil film.

Autographic positives

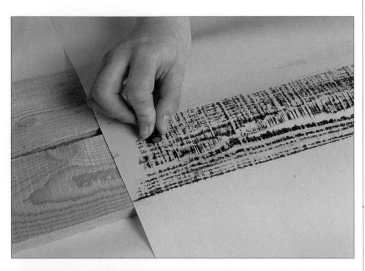

Autographic positives are handmade by the artist with opaque materials on transparent or translucent backings. It is the modern equivalent of the serigraph. The marks made by the artist are accurately translated by the stencil to create a printed image which is a true reflection of the artist's work.

The autographic stencil can be made in any number of ways such as painting with opaque ink on to tracing film (see Chapter 5), by spraying with an airbrush or spray gun on to film, by drawing directly on film with soft black crayons (toothed tracing film is available which is rather like drawing on a litho plate), by taking rubbings with black waxy crayons to produce textures (frottage), by collaging discrete forms to produce an amalgamated image, stippling with a sponge or fabric or simply coating objects with black ink and contact-printing them on to tracing film. Pre-worked screen stencils can be printed on to transparent sheets, with any color that is UV safe — black, red, amber — and re-worked to produce new stencils. The possibilities are endless.

Frottage (**right**)
The artist intends to include a textured area like knotted wood as part of an autographic stencil. A sheet of thin tracing film is placed over a piece of pine and the texture is picked up by rubbing over it with a soft black waxy crayon (**above right**). This frottage may then be used as an autographic positive with a photostencil (**right**).

Spraying (**left**)
Spraying is used in the stencil-making process to approximate continuous tone. Use a medium that is opaque to ultraviolet light. Black ink is completely opaque, but red or orange masking fluid (used here) is slightly translucent so the artist can see what is underneath.

TERRY WILSON
Anonymous Portraits 5 and 6

Autographic screenprints made by
drawing and painting onto the stencils.
The paint was applied using a range of
techniques — flicked with a paintbrush
and splattered with a toothbrush.

Photopositives

The potential range of photopositive is so vast, that to effect even an introduction to it requires a minimal photographic knowledge. Before attempting to make photostencils, the artist should understand about the timing of exposure, aperture opening, depth of field, grain size relative to film spread and have a rudimentary knowledge of developing and printing photographs. The most basic photopositive can be made by placing opaque objects on a sheet of high-contrast lith film (see below), which is then exposed, developed and fixed. But the simplest truly photographic image can be made by enlarging 35mm black and white negative film on to lith film. Incidentally, if a high-contrast photographic print or photocopier print is coated with liquid petrolatum on the back, the paper becomes transparent enough to use as a positive. This does not work with resin-coated papers.

PHOTOGRAPHIC IMAGES

Film positives provide the opportunity to combine photographic and autographic images. There are two types of photographic image, continuous tone and line. A continuous tone film is familiar to anyone with a camera — it is the "normal" type of film which reproduces all tones from black to white. Line film, on the other hand, reduces the image to black and white, like a silhouette. The implication of continuous tone is that every possible tone from black to white (or color) is on the negative. If the negative is magnified, however, it will be found to be made up of tiny, similarly-shaded particles, which are more concentrated in the dark areas than the light.

CAMERAS AND ENLARGERS

To make a photopositive, first the image is photographed with a camera. The image may be some artwork or a painting or simply a person or landscape. This image is developed on to continuous tone or line film which is then enlarged on to photostencil film.

There are many different makes of camera and enlarger which will produce reasonable positives. The range of 35mm, 2¼in square, 4×5in and 8×10in formats are all usable with any of the films mentioned in this section. The only thing to bear in mind when purchasing equipment for enlarging, other than cost, is that the larger the format of the negative, the higher the quality of the positive and the more flexible the system for experimentation — it is difficult to mask or register 35mm film, but relatively easy to do it with an 8×10in film. A positive register system, made by punching a set of holes which correspond to pins in the head of the enlarger, enables a number of films to be exposed in absolute registration. It is worth remembering too that an enlarger can double as a camera if it is fitted with copy lights.

HALF-TONE

In printing, inks cannot reproduce continuous tone, so it has to be approximated by breaking the tonal range of the image into distinct dots or marks which are quantified — 90 per cent dots = dark, 10 per cent dots = light. The most common use of this method — known as half-tone printing — is seen every day in newspaper photographs and advertising posters.

The half-tone effect is achieved by placing a half screen in contact with either the negative in the carrier or the image on

ALLEN JONES
Car '68

The point of departure for this 1960s car was a photograph developed on continuous tone film which was then enlarged on to photostencil film with a half-tone screen interposed to make the positive.

BEN JOHNSON
Sainsbury Centre

Here the perforations in the blinds impose their own grids of dots vying with the much smaller dots of the half-tone screen. To maintain the color subtlety of the original photographic image, this four-color separation was printed with tinted colors rather than the trichromatic colors and then three intermediate separations were added.

the bed of the enlarger, or by interposing a screen between the artwork and the film in the camera back if a process camera is used. This contact screen breaks up the image into a regular dot matrix in the case of a half screen and an irregular dot in the case of mezzotint. The regular dot pattern of the half-screen is very difficult to work by hand. Consequently the artist may find the mezzotint, with its affinity to sprayed dots, more useful if creative decisions are to be made and effected.

Dot matrix stencils always produce moiré patterns if one of them is overprinted with another. To limit this, the mezzotint screen should be moved through at least 10 per cent each time a new positive is made from the same source material. In the case of the four-color half-tone reprographic process, the screens are moved through 30°, 15°, 15°, as the rulings on the screen for the yellow printer are angled at 45°, the magenta 75°, the black 90° and the blue 105° to any common side. If half-tone positives are applied to the mesh, they should be rotated until coinciding moiré with the mesh fabric is eliminated; this may mean that an image will have to be placed diagonally on the screen.

POSTERIZATION

Posterization is an alternative way of creating an illusion of continuous tone. This is achieved by printing a number of over- and under-exposed line film positives made from the same negative with sequential exposure. To exploit this, a continuous tone negative or transparency is projected on to a sheet of light-sensitive film and a test strip is made using a number of exposure times. A selection of these exposure times is made with the intention of producing evenly spaced, tonal separation. Those separations are then enlarged to produce positives — the greater the number, the closer the approximation to continuous tone. If enlargements are made using positive material (eg color transparencies), it is advisable to work with full-size negatives as they are easier to hand work, and at any time new positives can be made by merely contact printing them; it is exceedingly difficult to re-size an enlargement once the image has been removed from the carrier. When posterizations are printed, opaque inks can be used to print from light to dark, or transparent inks can be similarly used or printed in reverse order from dark to light.

GERD WINNER
Harrison's Wharf

The technique used here is more
sophisticated than conventional
posterization in that negative masks were
used to eliminate some areas of colour.

WENDY TAYLOR
Iguana

Posterizations made from a pastel drawing
were printed with transparent inks from
dark to light to create a continuous tone effect.

ANDREW HOLMES
Thermo King

A combination of posterized,
photographic and hand-cut stencils on to
which the artist has added further hand-
made painted stencils were used for this image.

Stencil films for photopositives

For the purpose of making photopositives, you need black on transparent film base, which is in fact pink due to an anti-halation backing that remains until they are fixed. There are, of course, many types of film available that are not mentioned here. The films discussed below are best for the artist or small studio as they can all be processed using the same chemicals.

LITH FILM

Orthochromatic film is a high contrast film that can be processed under red-safe lighting conditions in a processor or by hand using conventional dish developer, stop and fixative. Lith film produces an image that is either black or transparent; there are no intermediate tones. When exposed to continuous tone negatives and transparencies, the ratio of developed black film to transparent base can be adjusted by altering exposure and development times.

There are two basic types of lith film — general purpose orthochromatic and panchromatic. General purpose orthochromatic lith film is the most useful for hand processing as it permits a wide latitude in exposure and development. Panchromatic film is principally used with filters to produce color-separated stencils for four-color printing (see below right). Because of its sensitivity to the whole color spectrum, panchromatic film needs to be processed in total darkness. Although it is sometimes recommended for use with a dark green filter, this is of little practical use. Both are available with thick and thin backing sheets or bases. If work is to be tightly registered, the thick base film, which is more expensive, is slightly more stable. The thin base films can be used to reverse images by exposing through the back. Both types of film can be processed by hand, but also come in rapid access form that is used for automatic film processing.

DUPLICATING FILM

Another type of film used for creating photostencils is duplicating film. This is also orthochromatic (ie, it may be used with red light). It is a reversal film which produces a positive image from a positive original or a negative from a negative original. So if a color transparency is placed in an enlarger and projected on to duplicating film, it will be reproduced as a black and tonal transparency. As this is a reversal film, under-exposure produces an image that is too dark, and over-exposure gives one that is too light.

DAYLIGHT FILM

A most useful contact film, if a UV light source and contact frame is available, is a daylight film — positive or negative. Positive film produces the same image to that which is contact printed, a particular use being to increase the contrast of drawings which are too light; negative film produces the opposite image.

AUTO-SCREEN FILM

If half-tone positives are needed, and screens to produce them are unavailable, there is a film called "auto-screen", a negative film with a dot matrix applied.

STENCILS FOR FOUR-COLOR SEPARATION

This is the system that is used to print most color artwork and photography in books, magazines and posters. In simple terms, it is based on the principle of photographing the original color image through a series of filters — red, blue and green — that produce positives that print respectively only cyan, yellow and magenta (the trichromatic primaries). The fourth color is black, which is produced by exposing all three filters in sequence on to the same negative.

The color filters required for four-color separation are red filters numbers 23A, 24 and 29, blue filters numbers 47 and 47B, and green filters numbers 58 and 61. Color separation requires particularly conscientious film processing as the slightest variation in exposure times can produce a color bias in the positive that when printed may lead to a muddy image. This is caused by degraded color in both the photographic and printing stages.

When making your own four-color separations, it is a good idea to develop a simple system that enables you to identify each filtered negative and its respective positive. For example, if no corners are cut off the red filter negative and its corresponding cyan positive, you may then cut one corner from the blue filter negative and the yellow positive, two corners from the green negative and the magenta positive, and three corners from the black negative and positive.

Red filter | Blue filter

Green filter | All filters

Color separation
The original color image (1) is photographed through a red filter to produce a cyan positive (2), a blue filter for the yellow positive (3), a green filter for a magenta positive (4) and, finally the black positive is produced by exposing all three filters in sequence on to the same negative (5). To identify each filtered negative and its respective positive, cut off the corners progressively.

Developing photostencils

As has already been mentioned, the films discussed can all be processed with the same chemicals which are suitable for the artist or small studio. Lith developer usually comes in two packs, A and B, each of which is diluted 3 parts water to 1 part chemical, before being mixed together to produce the working solution. (Rapid access developers are usually sold in a single pack ready for use.) Developers have a recommended working temperature of 68°F. However, if they are slightly warmer, 70—72°F, a greater range of exposed images may be produced from the same source material such as a negative.

Photographic work should be completed in small batches because developers start to oxidize and deteriorate as soon as they are mixed. The optimum development range for lith materials is between 2½ and 3 minutes. It is best to consult the manufacturer's information sheet provided with each film. The state of the developer can be observed in the time it takes for the image to appear on the film. Normally, this should be

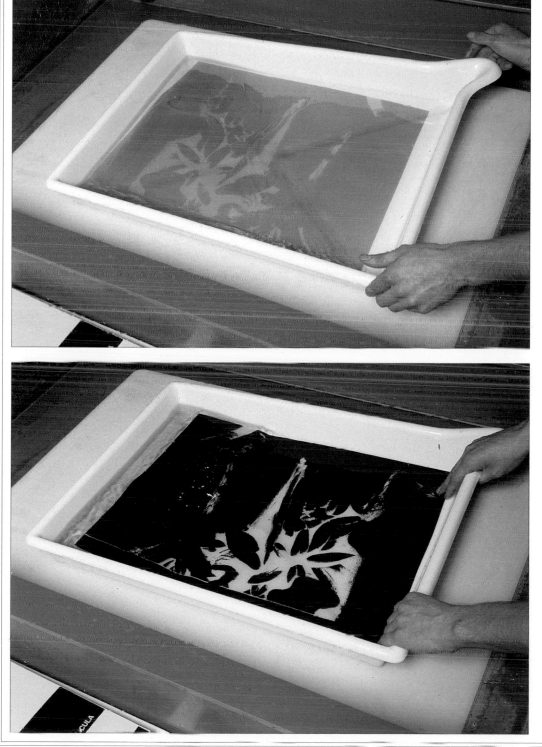

Developing the film
The photopositive film is developed in a shallow dish containing lith developer diluted with water as recommended (**left**).
The image should appear after 45 to 60 seconds (**right**).

between 45 and 60 seconds into the development time. If it takes longer, the developer needs renewing.

If a contrasting image is required, the developer should be vigorously agitated in the dish, taking care not to splash it. Detail can be achieved with the "fine line technique" which involves the gentle agitation of the dish until the image appears and intermittent agitation (5 seconds in every 30) until the image is fully developed.

A stop bath negates the action of the developer and thereby prolongs the life of the fixative. Stop has a color indicator which changes when it needs renewing. It can be stored after use until that time.

FIXATIVE

Fixative should be diluted in the ratio of 3 parts water to 1 part fixative. A rule of thumb is that film should be in the solution three times the clearing time of the anti-halation backing. So, if it takes 20 seconds for the pink backing to go transparent, the film should be left another 40 seconds. Fixative can be stored after use until it begins to take too long to clear. The fixed positive should be washed for about 10 minutes in running water and dried, in a dust-free cabinet.

The processing of positives in the darkroom and the manipulation of the images produced is an area open to creativity and experimentation. In the darkroom, the ability to actually see what is happening in the developer can be improved by under-lighting the development dish with a safe light.

Darkroom layout should be practical in as much as one process should lead to another. A surface on which film can be placed or cut should be adjacent to the enlarger. The development sequence of develop, stop, fix and wash should be arranged so that the operator knows where everything is, even in total darkness.

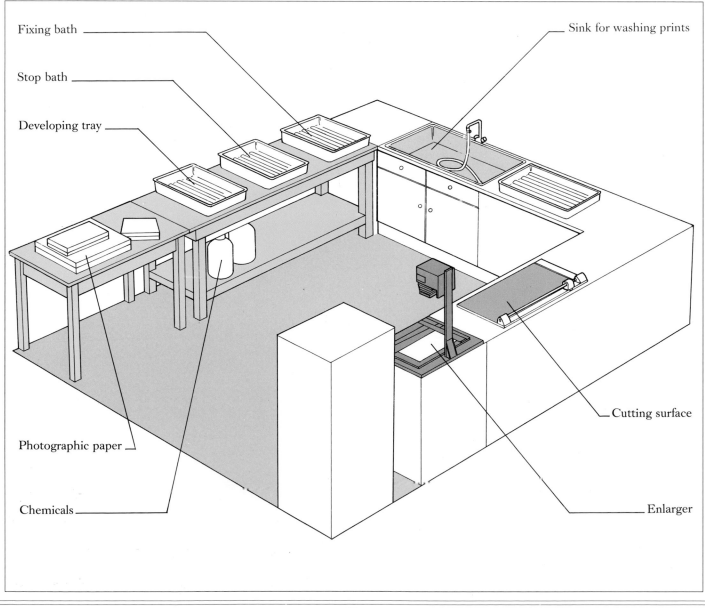

Fixing bath

Stop bath

Developing tray

Sink for washing prints

Photographic paper

Chemicals

Cutting surface

Enlarger

TIPS ABOUT STENCILS

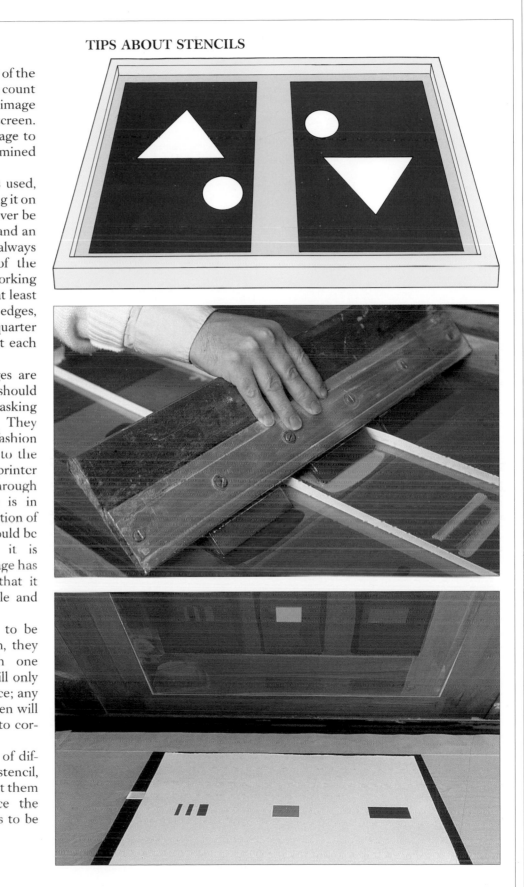

■ As a general rule, the quality of the stencil will determine the mesh count of the screen: a fine half-tone image cannot be applied to a coarse screen. Usually the relationship of image to mesh is one which can be determined by common sense.

■ Whatever type of stencil is used, care should be taken positioning it on the screen. A stencil should never be placed too close to the frame and an adequate ink reservoir must always be available at both ends of the squeegee run. A general working guide is that there should be at least 4in on each side of the running edges, and a reservoir of about one-quarter the length of the open area at each end of the print stroke.

■ If two or more large images are placed on single screens they should be placed to provide ease of masking while each is being printed. They should also be placed mirror fashion in the same position relative to the edges of the frame, so that the printer only needs to turn the frame through 180° and the second image is in approximate register. The position of large images on the screen should be carefully predetermined, as it is unfortunate to find that an image has been placed in such a way that it hangs off the end of the table and cannot be registered.

■ If a number of colors are to be printed with the same screen, they should be in register with one another so that the printer will only need to register the image once; any other colors on the same screen will only need slight adjustments to correct their registration.

■ If two or more small areas of different colors are on the same stencil, it is a good idea to try and print them together, as this will reduce the number of times the print has to be handled and registered.

PRINTING THE IMAGE

To print successfully you first need the right equipment. This need not be expensive; many items can be made at home. Equally important is arranging a convenient studio layout and maintaining an orderly approach to your printmaking.

The printing table

There are as many different designs for homemade tables as there are for home print studios. The advantages of the system illustrated here is that screens of different sizes can be easily fitted with the C-clamp on to the hingebar. Provision for "lift off" (the gap between the screen and print bed) is determined by the height at which the rear of the frame is clamped. The front lift may be provided by cardboard stuck with double-sided tape to the front corners of the screen. The counterbalance system means that the front of the bed is not encumbered with stays.

The points to consider with regard to any printing table are that the rear hinge assembly should be strong enough not to move so that front to back registration can be maintained. It should also have a master frame on to which different sizes of screen can be rigidly clamped. Finally, lateral movement should be prevented by a positive front locking system. The table itself should be solid enough to prevent movement or "flexing" while printing and have a quiet vacuum motor attached to a vacuum base, to hold the paper and effect lift off.

If a commercially produced table is bought, it should, however, be as large as is practical, not only to make large images, but also to allow small prints to be printed in different positions. Large frames enable a number of stencils to be used with only one screen, the print being registered in different positions underneath it. The counterbalance system should be adjustable to allow the operator to lift the screen with a minimum of effort.

The vacuum base, a thin rectangular box with holes on the top side attached to a vacuum pump below, provides suction to hold the paper still while printing, and to prevent the paper sticking to the screen once it has been printed with ink. The vacuum and lift off together determine the quality of ink deposit and, on commercially-produced machines, the vacuum is operated automatically only when the image is printed. When the screen is raised the vacuum automatically shuts off so that the paper can be easily registered. The master frame should be adjustable in height, to enable different thicknesses of stock to be printed underneath it and, most importantly, to allow for lift off. The vacuum motor should be quiet in operation, and be powerful enough to hold the largest sheet of paper, printed all over with thick ink.

LIFT OFF

"Lift off," "off contact," or "snap" are different names for the gap between the underside of the screen and the print bed. The reason for having this gap is that, without it, ink would flood under or run into the image when a print was pulled. As the squeegee is pulled across the screen, the front edge of its printing blade presses the mesh into contact with the stock, forcing the ink through the mesh and the stencil. As the squeegee passes across the mesh, the fabric behind the blade lifts off the printed image.

The height of the lift off is determined by a number of factors, such as the size of screen, the extent of the open area of the stencil, the tension of the mesh, the thickness of the ink and the pull of the vacuum. The screen size and open printing area of a large screen will require more lift off than a small one. The tighter the fabric is stretched over the frame, the smaller the gap needs to be. Thick ink tends to behave like glue, sticking the paper to the screen unless the vacuum is efficient. Thin ink on the other hand lifts off easily. The vacuum will not work efficiently if the holes around the edge of the stock are not properly masked out.

The height of the lift off also affects the accuracy of the registration, as the greater the gap, the more the stencil distorts. The lift off should never be so high that the printer has to force the mesh down on to the bed. If so, the stencil may be fractured by the edge of the squeegee blade.

If an artist wishes to print on a vertical surface such as a stretched canvas or a piece of sculpture, lift off can be achieved by sticking pieces of cardboard to the underside corners of the frame with double-sided tape. The thickness of the cardboard should be determined by the size of the stencil; a rough guide is 1/8in of thickness of cardboard to 1in of stencil.

Homemade printing table
A conventional printing surface can be made with a sheet of 3/4in thick Formica-laminated plywood, 6in larger all around than the maximum size of paper you intend to print. Fix this to any sturdy table. A hingebar made from a 2×2in section block of wood should be attached by large hinges to one end of the board. Clamp the screen to this with two C-clamps. Attach a weight with wire to the threaded handle of the clamp to counterbalance the screen. A homemade vacuum bed can be made with a vacuum cleaner.

Lift off
It is essential that there is a gap between the screen and print bed to prevent the ink flooding under the stencil. This gap is known as lift off.

Getting ready for printing

During the course of printing the following materials should be handy: masking tape, cellophane tape, invisible tape and double-sided tape. Masking tape is used in any circumstances when a low tack is required as it is easily removed. It should not have direct contact with the ink. Cellophane tape and invisible tape are used on or under the printing surface to mask or correct stencils. (Note that tape can be used on the underside of the screen with indirect stencils to remove parts of them deliberately.) Blue and red filler plus brushes should be available to make any corrections or to touch up any leaks during printing. A ruler, pencil, scissors and knife are usually needed during the initial registering of the stencil. To facilitate printing, a squeegee no larger than 2in on each side of the image should be used; the longer it is, the more effort is needed to manipulate it in printing. A number of palette knives will be needed — their size will depend on the volume of ink mixed (use 6in blades for 1 gallon cans and 10in blades for 5 gallon cans), as will ink containers. If solvent- or oil-based inks are used, containers should be made of tin or polypropylene, not plastic. The rag for cleaning up should be absorbent cotton. Many of the new paper substitutes are not absorbent enough, and merely move the ink about on the screen. Finally, a large pile of newsprint should be available to test the quality of the printed image, rectify any mistakes such as "tears" from the back of the squeegee (these may be blotted and then reprinted) and for cleaning up.

DRYING RACKS

The paper on which an edition is to be printed and the rack in which it is to be stored while drying should be as close to the print table as possible to minimize effort by the printer.

There are three different types of rack: the ball rack (or its equivalent which may be homemade with wires and pegs); the studio drying rack, which is a series of spring-loaded trays; and the tunnel dryer, a conveyor belt which takes wet prints through heater and cooler units and stacks them dry at the end of the belt.

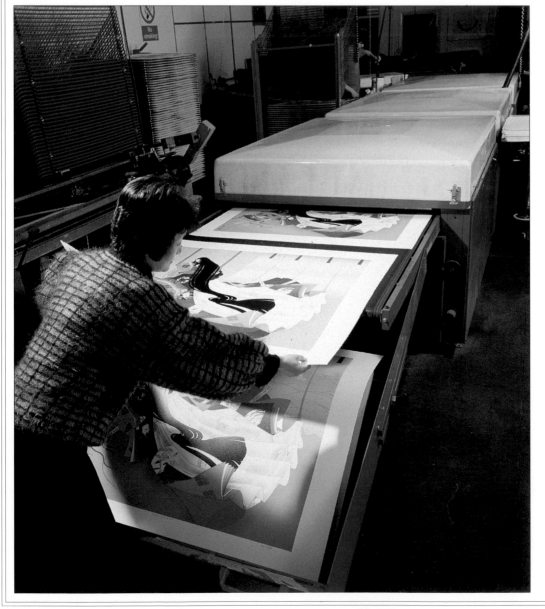

Tunnel dryer
This method of drying prints is generally found where printing is executed on a large scale. The wet prints are placed singly on a conveyor belt which carries them through heater and cooler units to stack them dry at the end.

Studio drying rack
Left This drying system consists of a series of spring loaded trays on to which single prints are laid to dry. The detail shows how the prints should be allowed to project by 3in from the front of the trays to make de-racking easier.

The studio should be set out in such a way that the need to move around it is minimized. As each individual studio will have its requirements determined by its area and the amount and type of equipment used, to do more than show a schematic layout is impractical. This layout shows what is necessary, and what to avoid. Most of its recommendations are a matter of common sense — wet processing should not be adjacent to paper storage, ink mixing should be carried out in daylight conditions or at least in a constant color-corrected artificially-lit area. Some processes have health and safety implications such as ultraviolet light sources, from which operators must be screened. Darkrooms and any wet areas in which electricity and water are used together must be protected by a micro circuit breaker (MCB).

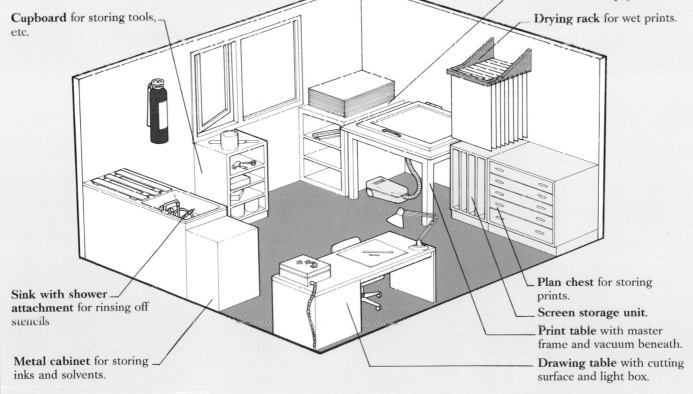

Cupboard for storing tools, etc.

Feed table with storage underneath for paper.

Drying rack for wet prints.

Sink with shower attachment for rinsing off stencils

Metal cabinet for storing inks and solvents.

Plan chest for storing prints.

Screen storage unit.

Print table with master frame and vacuum beneath.

Drawing table with cutting surface and light box.

Taking a print

The print bed should generally be set up so that the stock, the printing surface and the mesh are parallel. If one edge of the screen is higher than the other, the resulting image will be "out of true" or distorted.

If professionally made tables are used, you may find it easier to print if the back of the table is raised by about 12in using bricks. This has the effect of reducing the stretch for the printer to the back of the screen, aiding the pull pressure by encouraging the printer to use his weight, as well as strength, to pull the print downhill. This makes long print runs a lot less tiring to produce. In addition, visual registration is made easier as it reduces parallax (see page 64). Also, if a one-arm squeegee is used, the tendency for the ink to run to the back of the screen is reduced. Finally, it has the unexpected bonus of preventing the print table from becoming a surface on which things are stored.

Although there are other ways of printing, the method outlined on this page is generally regarded as the cleanest and most efficient. The screen is always kept wet, so there is no "drying in" problem, and the ink is printed for only a minimum distance; it is tiring and fruitless to pull ink across large tracts of screen where there is no stencil image. Furthermore, the ink should not reach the front or back of the frame, so the squeegee handle and the printer's hands remain free of ink.

Larger images are more easily printed laterally using a one-arm squeegee attached to the back of the table on an arm. If this type of squeegee is used, the system of flooding and printing is similar to that of hand printing, but the print stroke should travel toward the register corner of the stock. This is known as printing into "lay."

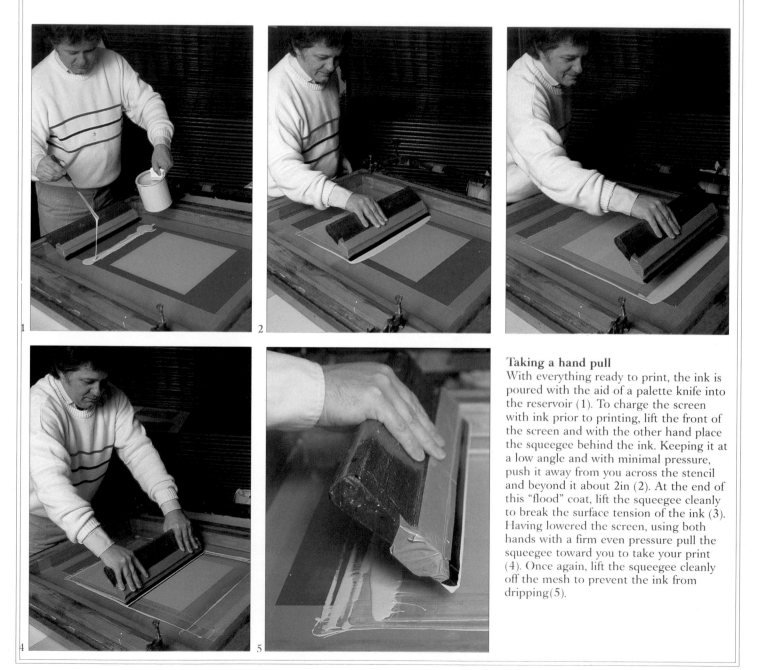

Taking a hand pull
With everything ready to print, the ink is poured with the aid of a palette knife into the reservoir (1). To charge the screen with ink prior to printing, lift the front of the screen and with the other hand place the squeegee behind the ink. Keeping it at a low angle and with minimal pressure, push it away from you across the stencil and beyond it about 2in (2). At the end of this "flood" coat, lift the squeegee cleanly to break the surface tension of the ink (3). Having lowered the screen, using both hands with a firm even pressure pull the squeegee toward you to take your print (4). Once again, lift the squeegee cleanly off the mesh to prevent the ink from dripping(5).

KEEPING CLEAN

As the borders of the print usually need to be kept clean, the printer needs to have clean hands, so the following tips may be useful. Use small pieces of paper to hold the ink cans when pouring ink. A palette knife will help direct and control the ink when pouring it into the reservoir. As it is desirable to keep any cleaning to a minimum, the table on which the ink is placed during printing should be covered with newsprint, which is simply thrown away once the printing has been completed.

GENERAL PRINTING ADVICE

Printing should never be a case of brute force overcoming incorrect printing technique.

Generally speaking, it is easier to print correctly rather than badly. Even though good printing technique will never resurrect a mediocre image, it will make its production less painful. If the counterbalance weights of the press are correctly adjusted, the screen irrespective of size should be able to be lifted using a minimum of effort. If the squeegee blade is soft and sharp, correctly thinned ink can be printed through the finest detailed stencils on to fairly coarse papers.

Most problems encountered in printing can be resolved with a little common sense. If, for example, everything has been correctly processed, the ink, squeegee, and stock are compatible, but the ink fails to go through a photostencil, it may be that the backing sheet has not been removed. If a photostencil has not been correctly processed, it will not stick to the screen; if it has been inadequately washed out, ink may not print in localized areas, due to film residue drying in the open stencil areas and forming a scum.

CLEANING UP

There are a number of general purpose cleaners available to remove ink from the screen if a color needs to be changed, or to remove all traces of ink prior to screen reclamation. The compatibility of these cleaners with the printing ink should be established by reading the manufacturer's instructions.

Cleaning up is the bane of screenprinting. However, the following procedure if followed makes it fairly quick and painless. A wad of three or four sheets of newsprint is placed under the screen. The ink is collected by the squeegee and brought to the front of the screen, where it is collected on to the blade against the front inside edge of the frame. The ink can is placed in the screen so that the ink can be scraped off the squeegee into the can using the palette knife. This is repeated until most of the ink is in the can. The small quantity left in the screen is removed with the palette knife, and the screen finally wiped with a rag. The top sheet of newsprint is thrown away and the screen is then cleaned with a rag and a solvent suitable for the type of ink, or water for water-based inks, rubbing it into the next sheet of newsprint. This is continued until the screen is clean, when the remaining solvent is absorbed with a clean rag on to clean newsprint. The trick is to make the rag and newsprint do most of the work.

Cleaning the screen
Place a pad of newsprint under the screen (1). With the squeegee, scrape the ink to the front of the screen, collect it on to the blade and transfer it back to the can (2). Now clean with rag and appropriate solvent (3).

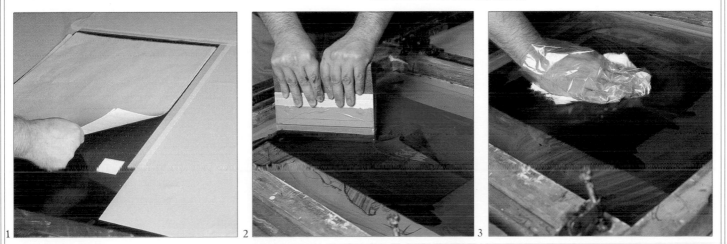

1 2 3

Registration techniques

R egistration is the means by which the paper is positioned in relation to the screen and stencil. Correct registration will guarantee that a single color is printed in an identical position on any number of sheets of paper.

REGISTERING A PRINT WITH "LAYS"

For successful registration the position of the stencil relative to the print bed needs to be constant. A reasonable quality print table should prevent any horizontal screen movement from taking place when it is clamped into the master frame. The problem is to make sure that the paper is always placed in exactly the same place on the print bed. This is achieved by using "lays," three small rectangular pieces of cardboard or plastic taped to the print bed.

Once in position, it is good practice to tape the lays to the bed, in addition to the double-sided tape, to guarantee no movement during editioning: the lays should be located in such a way that the printer can feel that the paper is tightly touching the lays, rather than relying on sight.

The first sheet printed should have the position of the lays marked on it, so that the lays of subsequent colors can be placed in the same relative positions. An arrow indicating the direction of the printing stroke should also be penciled on this first sheet. This is because the screen stretches slightly when the squeegee is pulled across it, making it important that all colors are printed in the same direction.

SIGHT REGISTRATION

The simplest way of registering is called "sighting" or "sight registering." To do this, first the vacuum must be switched off, then a sheet of paper, on which one or more colors have already been printed, is moved about underneath the screen, until it is "by eye" in the correct position for printing the stencil which is being "sighted." If the screen is larger than the paper to be printed, two cardboard extensions can be taped to the sheet to allow it to be manipulated under the screen. When the print is in register, it is taped to the bed, the screen is raised, and the lays can then be attached in the same positions as they were for the previous colors.

Registering with lays
To make sure that the paper is always placed in the same position on the print bed, lays (rectangular pieces of cardboard or plastic) are used. Lays can be made by sticking double-sided tape to the underside of a small rectangle of plastic (250-400 microns thick) in a contrasting color to the print bed and then cutting it into three rectangles 1×2in. As can be seen below two rectangles are stuck on the table along the longest edge of the paper. With the paper tight against these two lays, the third rectangle is fixed on an adjacent corner. The two corner lays should be fixed $\frac{1}{2}$in from the actual corner of the paper as this often gets damaged making it difficult to register. Once the register is finalized, the lays should be additionally taped to ensure there is no movement.

LAY COPY.

PRECISION REGISTER BED

A precision register bed provides a refinement to this system, as it allows the bed to be moved a small distance in any direction. When the image under the screen is almost in register, the lock which prevents movement is released and fine adjustments are made by moving the bed. The paper is "in lay" and the vacuum should be on to prevent slippage of the stock. When the final register is correct, the bed must be locked as vibration of the vacuum motor and movement of the screen about the hinge will cause slight movements of the bed. If the lock is not engaged, the movement will be perceptible throughout the edition, when on a subsequent printing the registration of each print may be slightly different.

FLAP-OVER SHEET REGISTRATION

Another registration system that is often used incorporates a thin sheet of rigid transparent plastic (240-400 microns) as large as the stock. This is taped only to the front of the bed so that the tape acts like a hinge. The image is then printed on to the plastic sheet. To establish that the print is correctly regis-tered, it is placed under the sheet and moved about until it is synchronized with the print visible on the sheet. The plastic sheet is then carefully folded back from the print area, the screen lowered and the color pulled. This system can also be used if early colors have to be printed out of register and the printer wishes to compensate for this.

A REGISTER SHEET

The most accurate form of registration is achieved with a transparent register sheet. A print is placed approximately in register under the screen, then a thin plastic sheet is stretched over it (the backing sheet from photostencils is ideal). The sheet is stretched by taping the farthest corner from the printer to the bed; this is then repeated with the diagonally opposite corner, stretching the plastic in the process. This is then repeated for the other two corners. The image to be registered is then printed on this transparent film. The print underneath can then be moved to determine final register. With the print accurately in place, the lays are positioned and the register sheet discarded.

USING A PROFESSIONAL STUDIO

If an artist wishes to make an edition but does not have the facilities or the expertise to do this, there are a number of fine art print studios which specialize in making and editioning prints.

The economics of using a studio should be determined by various factors. (i) Do you have available the facilities to print and dry a large edition? (ii) Do you have the expertise and stamina to produce an edition using as many colors as is necessary to make the image, to an acceptable standard, on a finite number of sheets of paper (ie 20 colors×100 prints=2,000 pulls)? (iii) Most important, have you realistically assessed the value of the artist's time? Many artists are surprised to find that they have been making prints at an hourly rate equivalent to that of a junior printer. The best way to be introduced to a studio is to find a publisher who will finance the printing costs and artist's fee.

COMMUNICATION BETWEEN ARTIST AND STUDIO

This relationship, to be fruitful, has to be two-way: the artist presents ideas for a print, making demands on the studio to generate new ways of making images, and in return the studio extends its expertise and knowledge of the medium, making suggestions to improve the work and offering solutions to creative problems. The studio should be able to solve any technical problem posed by the artist and then translate this solution into a form which will print.

In the United States the person who solves the problems of translation is called a chromist or originator. Even though the draftsmanship and creativity of the chromist may exceed that of the artist, the executive decisions must be made by the artist of the print. At the outset of an edition, it is essential that the artist should discuss with the studio how the print should look and what is important to them in the printing process. The studio for its part should try to avoid making all their artists' prints look alike, because of convenient or repetitive techniques. If such a feeling of mutual respect develops between artist and studio, the resulting prints are more likely to be innovative as well as technically competent.

BAT PROOF

Proof of executive decision-making culminates in the BAT proof (BAT stands for *bon à tirer*, literally good to pull). This is the proof that the artist finds most satisfactory and wishes the printer to use as a guide for the edition. Although the BAT proof is used as a guide, changes still occur in the process of editioning that improve the quality of the prints, such as subtle changes in color or the addition of extra colors at the artist's discretion.

Registration problems

T here are three stages at which mis-registration is likely to occur: origination, processing and printing. If the original positives or stencils do not register, then it follows that it is unlikely that the print will do so. The accuracy with which stencils are registered during production will determine how accurately they will register when printed.

REGISTERING STENCILS

The most accurate means for registering stencils is called a positive register system. It consists of a specialized accurate hole punch (the larger, the more accurate), and some thin, rigid, transparent sheets (foils) for punching which are then placed on a line of pins which correspond to the holes. The pins, which are on a metal band, may be attached to a light box, drawing board or any working surface with double-sided tape. A stencil is drawn on, or stuck on a foil, which is automatically registered to any other which has already been produced by matching the punched holes to the pins. The advantage of this system is that at any time register can be confirmed by removing and replacing stencils on the pins, rather than by having to tape them together.

Another way of registering stencils is to use registration crosses. These are drawn on the four corners of each stencil from an original master drawing. Registration is achieved by aligning the crosses on the various stencils. The problem with this system is that the crosses are often drawn inaccurately or they sometimes get distorted when being processed. All the stencil register systems in the final analysis rely on visual accuracy in the initial registering.

The most difficult form of stencil registration is known as edge-to-edge, which means simply that one color should "kiss" another. Even if stencils are a perfect match, a negative and a positive from the same image, there will, when printed, inevitably be white spaces between the colors. This is due to paper movement, stencil distortion, instability of material or screen stretch. To overcome this, the stencils are under- and overcut. This means that if a light color is to abut a darker color, the light color is cut fractionally larger on the common edge so that the darker color can overprint it.

Your skill in using this technique will improve with experience and the size of these overcuts will decrease as you gain in competence. If the colors are pale or transparent enough to allow it, the edge-to-edge overcutting can be replaced by printing the paler color (sometimes by combining the two photostencils) under the entire overprint, removing the need for any edge registration.

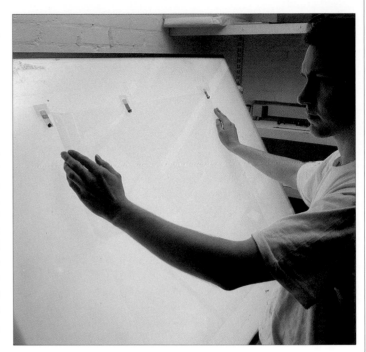

Positive register system
The transparent foil has been punched with a foil punch and is being placed on a line of "pins" taped on a lightbox.

Any stencil drawn or struck on the foil will register with any other punched and pinned in the same way.

MIS-REGISTRATION DURING PROCESSING

Mis-registration can also occur if the processing stages are not carefully performed. If a print is designed to be very accurately registered, then it has to be processed systematically. If a number of stencils need to be accurately registered, they should all be made at the same time, on similar-sized, pre-masked screens. The mesh counts and the position of the different stencils on the screen should be the same. If hot-washed indirect photostencils are used, they should be rinsed with cold water before bonding to make them return to their original size. Care should also be taken to avoid distorting or creasing the stencil material while it is being applied. Capillary stencils have one advantage over indirect stencils in that they are bonded to the mesh before being exposed.

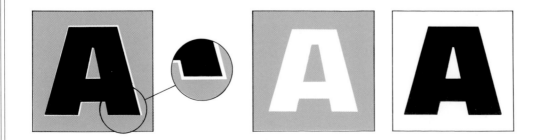

Edge-to-edge registration
In this form of registration, used to prevent white spaces appearing between the negative and positive stencils from the same image (**far left**), the light color (**center left**) is cut slightly smaller than the dark color (**left**).

BIANCA JUARREZ
Wrong Number

This print was registered by printing the
black stencil first in transparent gray to
provide an accurate key line for all
subsequent stencils.

PAPER AND REGISTRATION

Paper also presents problems for registration. If it is deckled,
it has to be notched or trimmed to provide registration edges
It should also be aged by being stored and, if possible, "racked-
out" for at least 24 hours so that it is acclimatized to the
printing conditions. If a tunnel dryer is to be used, paper
should be sent through it unprinted to stabilize it. Sized paper
holds its register better than unsized. If printing is to be car-
ried out on any new or hitherto unused stock, tests should be
made for both stability and ink compatibility.

MIS-REGISTRATION AT THE PRINTING STAGE

Printing itself can cause register problems: the weight and
angle of squeegee pull, the viscosity of the ink, the softness
and sharpness of the squeegee blade, are all variables which
will distort or stretch the screen. The mesh count, the tight-
ness of the screen and the height of the lift off will also have an
effect. To this end any changes which are knowingly made
should be noted in pencil on the print, and changes caused by
deliberately moving the lays once an edition is being printed
should be avoided. Because the squeegee tends to stretch the
mesh, the direction of the printing stroke should be in sym-
pathy with the image being printed. For example, if parallel
lines are to be printed, the squeegee should travel along their
length rather than across them.

CHECKING REGISTRATION

There are a number of ways that the initial register can be
checked for accuracy. A positive taped to a print will make
"sighting" easier, especially if printing posterizations. If the
positive is difficult to see against a dark background, slip a
sheet of tissue between the print and the positive.

When using pale colors and trying to line up edges, wipe
small areas off the edge of the image on the registration sheet
so that the continuation of the edge on the print beneath may
be seen. If a pale or white edge on paper is difficult to see, stain
the paper with watercolor to show where the ink is. If a color
is too transparent to see for registration, overprint it a
number of times to darken it.

Sometimes printing a medium color before transparent or
pale colors will make registration easier. If a number of colors
are to have a line around them, it should first be printed trans-
parently to provide a register key. When printing an edition,
every now and then overprint an early impression to check
that the paper or image has not moved.

PROBLEMS WITH THE MESH

One of the advantages screenprinting has over lithography
and etching is that, even though the mesh can distort, causing
registration problems, it can also be easily manipulated to
rectify them. There are many ways of doing this, such as by
locally stretching the screen with tape, increasing or
decreasing squeegee pressure and/or lift off, or, if the screen
has expanded due to atmospheric conditions, a fine water
spray (from a house plant atomizer) carefully applied to the
masked area will loosen it a little.

Printing with color

There are two aspects of color which concern the printmaker, one is esthetic — to do with choice or selection — the other is technical, concerning how this selection may be matched or mixed. The question of color choice is the prerogative of the artist, but the analysis by which a color is determined, and an assessment of how it will overprint, are technical matters which can be solved with the help of knowlege and experience.

Adept color mixing is part of the battery of skills required of the printer. A simplified explanation of how color is perceived may prove to be helpful. Pigments have the property to absorb some or all of the rays of visible light. Those that are not absorbed are reflected into the eye, where they are perceived as color by red, green and blue receptors called cones. The degree of darkness or lightness or shade is also determined in the eye by other receptors called rods.

COLORS FOR FOUR-COLOR PRINTING

The complementaries of the primaries red, green and blue are cyan, magenta and yellow, which are called the trichromatic primaries. The traditional idea that the primaries were red, yellow and blue was the result of assuming that yellow, because it could not be mixed with pigment, must be primary. If colors are mixed using the traditional primaries of red, yellow and blue, the resulting colors are muddy, whereas if the after-images — or complementaries — of the true primaries are used, mixed colors are both bright and subtle. These so-called printers' primaries of cyan, magenta and yellow are, in fact, the true secondary colors.

COLOR MIXING

The ability to mix or match colors accurately relies on experience, knowledge and patience. Most people can match two similar colors when shown color charts, but will fail to mix the same color accurately even when provided with its components. If a color is mixed by weight, using exceedingly accurate scales, small quantities of color may be multiplied mathematically to produce the quantities necessary for editioning. If a color is to be matched, knowledge of its properties — is it transparent, opaque or translucent, is it dark or light, and what is its color bias? — will at least help to ensure that the mix is correctly approached.

All color mixing or matching is affected by the light under which it is viewed. Fluorescent light, which is blue biased, will make yellows look greenish and reds dull, whereas tungsten (gallery lights) will enhance reds, greens and yellows to the cost of blues and mauves. The best quality of light is northern midday light. Although lighting manufacturers attempt to produce the same quality, they fail to explain that it is also a question of light quantity. One north light tube will not help in accurate color matching, whereas ten in the same area will.

COLOR PROOFING

If the printer is producing a limited edition from an existing original, then proofing is purely a question of checking to see that the colors reflect those of the original. If the print is to be made effectively on the print table, as in the case of a "serigraph," the approach to proofing is more a matter of progressive arithmetic. For example, if an image is to be printed in red, yellow, blue and green, the possible selection of different, say, yellows is vast. Therefore a limited number should be selected, perhaps three, and followed by versions of the subsequent colors, to determine which print is to be editioned. If three versions of each of the four colors were to be proofed, this would mean having 81 slightly different prints. As an economy these color proofs could be printed on cartridge or even poster paper.

Color wheel (left)
The trichromatic primaries — cyan, magenta and yellow — on the outside of the wheel when mixed together produce the additive primaries in the center.

Four-color separation (above)
In color printing an image is "separated" into small dots of the three trichromatic colors and black (**above left**). Combined together in various densities, different shades and hues can be printed (**above**).

COLOR CHARACTERISTICS

Colors have the characteristics of transparency, opacity and translucency.

Transparent color is like stained glass. Transparent colors allow light to pass through them and reflect a color underneath — a transparent bright red when printed over yellow will appear orange. Transparent colors may be seen as glazes or tints as well as strong colors.

In printing, the more transparent an ink is, the less effect it will have on the underprint color. Transparency is measured as a percentage of the maximum intensity of a color, so that 10 per cent color will be 10 per cent pigment in 90 per cent transparent base. The more transparent an ink is, the less light fast it is. Transparent inks provide the maximum number of colors from the minimum number of printings — 2 transparent colors = 3 overprint colors, 4 transparent colors = 10 overprint possibilities.

Opaque color covers any color over which it is printed. All colors have a degree of opacity. However, it is usually more difficult to obliterate dark colors by overprinting than pale ones. Opacity can be increased by using thick ink, the consistency of molasses, and coarse meshes. Conversely, opacity can be reduced by using thin ink — black printed thinly through a fine mesh will read as gray. Generally speaking, opaque ink is more light fast than transparent ink.

Translucency is the tendency of an opaque color to become more transparent as a base is added to it. It will never be transparent because the nature of the original ink is to obliterate, but its quality is that of frosted glass. A translucent colour will make an under-print colour look like a tint of the overprint.

HUE AND TONE

The hue, or chroma, is a colour's particular characteristic — the redness of a red, the greenness of a green. When analyzing a colour in order to mix it, it is important to assess its colour tendency or bias. In the colour circle, red is between yellow and magenta, so if a red is to be mixed, it will need to be rated according to whether it tends towards yellow or magenta.

The tone of a colour is its tendency towards lightness or darkness. This again is measured as a percentage — 0 per cent is white, 100 per cent is black. Although a colour may not contain black, its equivalent tone can be identified on a grey scale. A colour may be reduced in tone or made lighter by adding either white or transparent base to it. A pale transparent colour gets darker the more times it is printed, but an opaque can get lighter.

Before looking at ways to make a color darker, it may be useful to analyze the characteristics of black when used for mixing. Black absorbs light, so, as color needs reflected light or order to be perceived, an alternative to black should be used to darken a color. If a color needs to be intensified, while still maintaining its chromatic value, this can be done by adding tinters. If, however, the color is to be tonally darkened then the addition of the complementary color will achieve this while still maintaining some resemblance to the original color.

Characteristics of inks
The characteristics of ink colors can be manipulated by the artist to produce a wide range of effects. Transparent inks (**above left**) can be overprinted to produce subtle colors. Opaque inks (**above**) if used thickly will cover most colors.
Translucent inks (**left**) have the quality of frosted glass and do not obliterate underlying colors completely.

Color tree
Colors can be reduced or intensified to produce different tones.

Blending color

Color does not have to be flat or consistent in hue. One of the most dramatic techniques available to the screenprinter is blending, or merging color. To use this technique two or more colors are carefully mixed on the screen using the squeegee, leaving the transition from one color to another visible. No two blends will be identical and what is acceptable is up to the artist.

Other techniques include the dribbling, splashing, painting and sponging of ink of one or more colors on to the mesh prior to printing with another. Drawings can also be made using wax or oil crayons on the mesh (preferably multi-filament) which is then transferred on to the paper when a pull is taken. These techniques are more applicable to mono-prints, which differ from print to print.

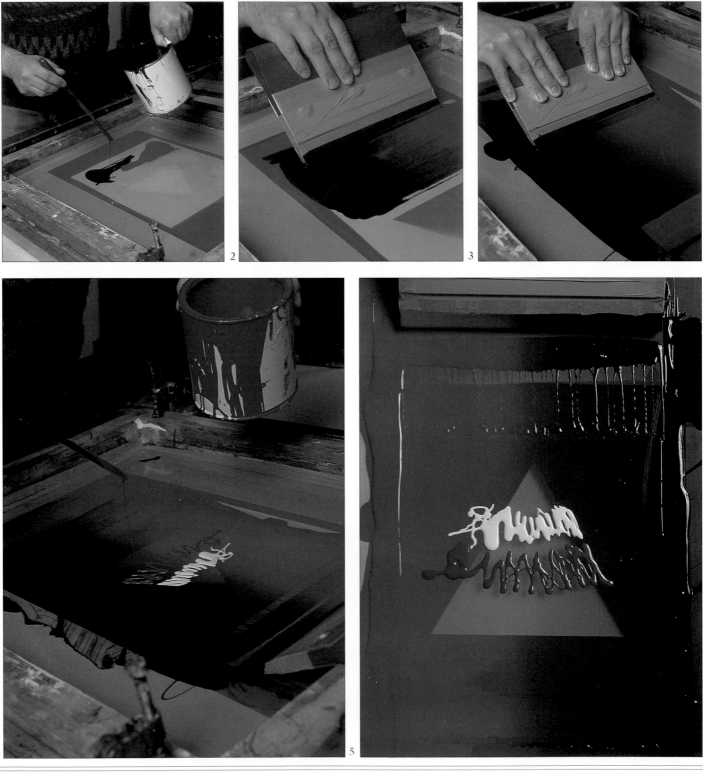

Using blended colors

The simple triangular print shown on this and the facing page was created using blended colors. Black and red inks are carefully poured in to the reservoir at the front of the screen (1). Using the squeegee, the two inks are merged (2). Next the blended ink is flooded back across the screen (3). This produces what seems like a gradated shadow across the red triangle (**above**). To develop the image yellow and blue inks are dribbled across the open mesh of the triangle (4 and 5) and printed to produce the finished image (**right**).

ANTHONY BENJAMIN
Canton 1, 2 and 3

In this triptych, the artist has blended his inks to arrive at the delicate transitions in tone and color spread out over the three parts of the work.

Part Five

SCREENPRINTING PROJECTS

The choice of stencil technique is central to the process of creating a screenprint. In order to illustrate the creative possibilities and practical application of each of the main stencil-making techniques, six leading artists were each asked to produce a print using a different method. In most cases the artists were asked to produce a print in only one day. To facilitate this a studio was put at their disposal and each was provided with a printer to assist them. The two exceptions were the late Norman Stevens of whose work the studio had a complete set of separations and colour proofs, and Ilana Richardson who happened to be making a print at the studio using one of the more complicated techniques.

Most of the projects described employed stencil-making techniques that could be adapted for use at home without the facilities of a professional studio or the expertise of an experienced printer. You may have to adjust the complexity of the image, or

the size of the print or the size of the edition to suit your own level and the equipment available. But even photographic stencils should not be thought of as being too complicated to exploit at home; the de Charmoy print on page 127 was made using a temporarily converted bathroom and the cheapest 35mm enlarger available at the time, and printed using, for the most part, home-made equipment.

As well as the commissioned project prints, each section includes a number of other examples of prints by professional artists that were created using the techniques described. In many of the prints the artist has used more than one technique as in *Rainbows on a Train* by Patrick Hughes, in which he uses autographic stencils combined with cut film. Although each project was created using a single stencil technique, it is one of the great advantages of screenprinting that the techniques can be mixed to create a wide range of different styles.

The complexity of the imagery ranges from the concrete poem by Henri Chopin (page 78), which uses cut paper stencils of the flags and enlarged photocopier film for the text, to the elaborate photographic compositions of Boyd and Evans and Jack Miller (page 125), to the delicate hand-sprayed stencils of the Brendan Neiland landscapes (page 112).

Paper stencils

P aper, whether cut or torn, provides a very immediate way of making stencils because no processing is required prior to printing. When the stencil is made, it is attached to the screen with double-sided tape, and the first pull is taken. The ink in the screen provides the main source of adhesion. The potential of this type of stencil is extensive, ranging from the torn figures holding hands, to the complicated monoprints of Arthur Secunda. By overprinting numerous transparent colors through carefully torn stencils, it is possible to produce images that are both subtle and sophisticated.

When using an existing image as the source material, it is first necessary to make a tracing of the main areas of the picture, and then to transfer each individual element on to a separate sheet of newsprint. These traced areas may be torn from the sheets to be used as stencils, (this is made easier by using a small ruler as a guide as for example does Sandra Blow).

The cut or torn paper technique may produce either negative or positive prints, depending on whether pieces are torn from a sheet and placed under the screen, or removed from the center of an intact sheet which is then used as the stencil. If the former method is used, a way of making sure that "floating" pieces of paper remain in position is to stick them to the screen using dabs of the ink to be printed, rather like glue. If the whole sheet is used, small pieces of double-sided tape can be stuck to the edges of the paper, to prevent it from falling from the screen when it is lifted prior to flooding.

ANITA FORD
The Third Bird

Sophisticated images can be made with
torn paper stencils. Here numerous
carefully torn and cut stencils, sometimes
softened with blue filler, have been
overprinted so that it is difficult to tell
from the result the precise technique used.

TORN PAPER STENCIL

The artist Sandra Blow RA was asked to make a print in one day using only cut or torn paper stencils. Within this time restriction she made an eight-color print based on a monochrome collage and successfully proofed each color a number of times until she achieved the result she wanted. The potential for experimentation which accompanies printmaking is of great interest to Sandra: her concern with color purity makes it an ideal medium in which to work. Sandra says that she sometimes thinks of her work as non-functional architecture.

1 The original monochrome collage from which Sandra worked.

2 Sandra traces the image on to tracing film which is then fixed to a light box. This allows the various elements of the image to be torn from sheets of newsprint and subsequently placed in the right relationship to one another.

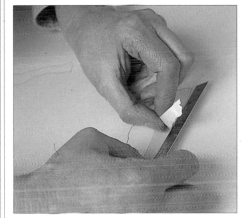

3 To tear small areas with a reasonable degree of accuracy, Sandra uses a small steel ruler as a guide.

4 The main red stencil is placed in position on a sheet of printing paper that has already been registered. The printer attaches small pieces of double-sided tape to the paper stencil to prevent the paper from being pulled off by its own weight when the first pull is made.

5 The paper, stencil and screen are all in the correct relationship to each other. The printer locates the spots of tape and checks that they will stick.

6 The screen has been lifted to show the slightly creased stencil now loosely stuck to the underside.

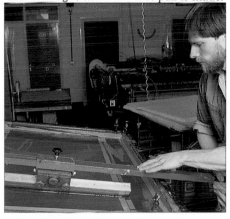

7 The first color is printed using a one-arm squeegee. The vacuum is not used for this first pull.

8 The first pull has successfully stuck the stencil to the mesh. The first color is dried and checked for position on the paper. When all is correct, the vacuum is switched on and the edition printed.

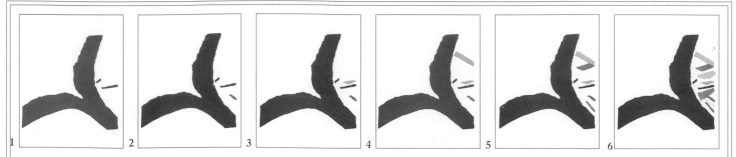

Sandra Blow: progressive proofs

Color is Sandra Blow's main concern —
particularly the balance of the individual
colors within the composition. These
progressive proofs show the painstaking
build-up of the composition in stages to
achieve the balance that she wanted.

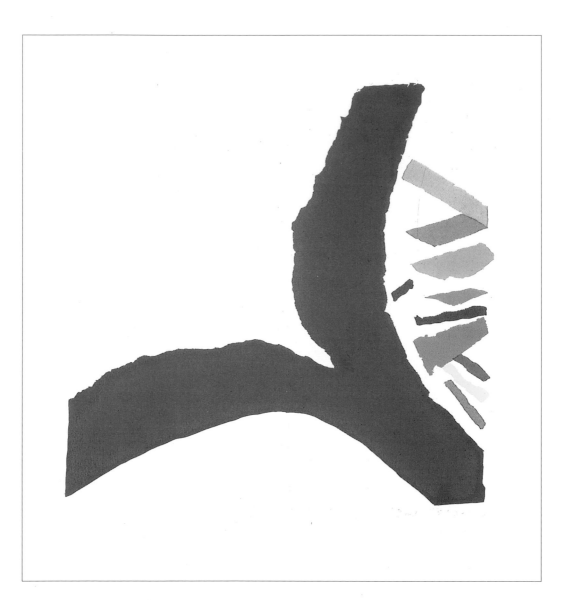

SANDRA BLOW
Vivace II

The final print includes an embossed edge
which was added to help with the location
in space of the elements of the
composition and to hold the image on the
paper.

TORN PAPER LANDSCAPE

A landscape can provide the source material for a simple print using the torn paper technique.

In the example used here, a rectangle stencil was first printed as a blend to produce the sky, and the other intermediate distances then overprinted using torn pieces of paper to create a positive image; to mask those colors which were regarded as correct, so that the foreground was the last area to be printed. The simple shapes combined with bold color produced a striking image.

1 Having first printed a blended rectangle, the sky is separated from the earth by masking it with a newsprint stencil. For all printings the position of the screen and lays remain the same.

2 The sky mask is stuck to the screen by pulling a print of the green to create the body of the landscape.

3 The earth and sky are differentiated. For the foreground the same mask for the sky remains stuck to the screen, 4 additional pieces of torn paper representing the various middle distances are positioned for printing.

4 More of the screen is masked and the foreground is added. This technique is easy to work with, but it is more fruitful if a real landscape or a photograph of one is used as a point of departure.

HENRI CHOPIN
Flic Flac Floc

This simple graphic image was produced
with a combination of cut paper stencils
and a photostencil of the typed text.

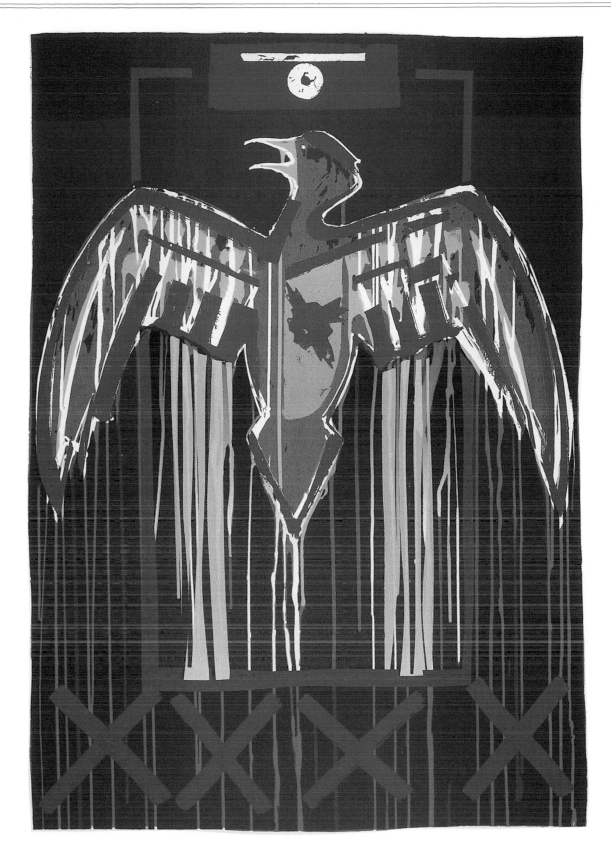

ANITA FORD
The Second Bird

Stencils predominantly made with torn
and cut paper and filler were combined to
produce this arresting image of a bird.

Cut film stencils

Knife-cut film stencils are used to produce accurate, detailed images that would otherwise require bridging pieces. These stencils, made from twin-skinned laminated stencil material supported by a backing sheet, are exceedingly robust; if they have been correctly stuck to the screen, they will withstand thousands of printings, and are therefore suitable for large editions and commercial printings as well as fine art editions. This technique has been successfully employed by many artists to create posters, postcards and fine art prints. Depending on the stencil material selected, knife-cut film stencils can be used with watercolor, oil- or water-based ink. For more information about the use of this technique, see page 40.

PATRICK HUGHES
Rainbows on a Train

A classic knife-cut stencil.

KNIFE-CUT STENCIL USING WATER-BASED FILM

Patrick Hughes was asked to make a print in a day, using only the cut film technique. The print he created was based on a watercolor painting from which he produced an accurate line drawing. The stencil for each color was made by placing a piece of film over this drawing and cutting out those areas to be printed. The stencil material selected was water-based film. Originally six colors were planned. However, during printing it was decided to add further colors. Patrick suggested that it could be personalized by adding the name and address of the person for whom it was intended on the printed envelope.

1 The stencil film is cut using the minimum pressure so that the backing sheet is undamaged. Patrick is using a former to reproduce the repetitive curves.

2 Having cut the film, the area to be printed is carefully peeled away from the backing sheet.

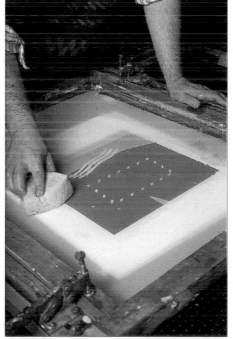

3 The prepared screen is placed over the stencil and a wet cellulose sponge is rubbed firmly over the entire surface of the mesh, attracting the water-based stencil material. As the surface is wetted it changes color.

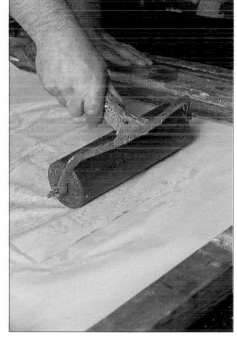

4 The excess moisture is blotted off with newsprint and a roller and allowed to dry.

Continued overleaf

Continued from previous page

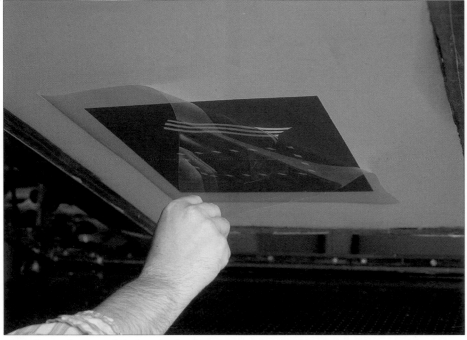

5 Once the stencil is dry, the backing sheet is carefully removed.

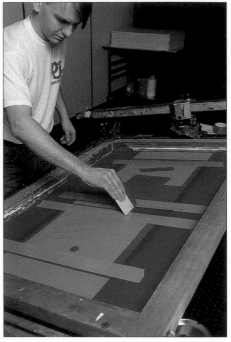

6 Because this print is relatively small two of the stencils that will make up the final image have been put on the same screen, the printer has masked the open areas of the stencil so he can apply filler between the two stencils without covering the areas to be printed.

7 The image which is not to be printed at this time is masked with poster paper to protect it from ink. The image is now ready for printing.

8 Patrick looks at the finished print and checks that the printed colors match his original specifications.

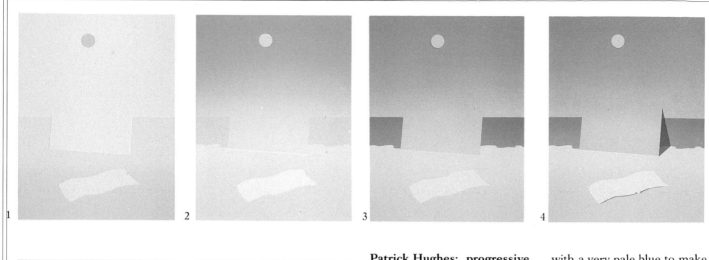

Patrick Hughes: progressive prints

The first two colors yellow (1) and blue (2) were printed as a blend from left to right so that the color graduates from dark to light. As the combination of blue over yellow did not, in the artist's opinion, make a satisfactory sea-blue, the sky was masked out and the sea printed over in a darker blue (3). The shadows under the beach towel and behind the letter were added (4). Then the envelope was overprinted with a very pale blue to make it appear whiter than white (5). Finally the red touches on the towel and letter were added using the same screen as the blue (see final print below), with one color being masked while the other was printed (6).

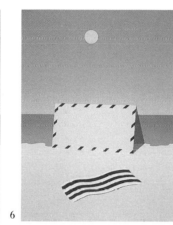

PATRICK HUGHES
Home and Away

As we have seen, apparently simple knife-cut screenprint involved the artist in precision cutting. Even though the design is stark, Patrick Hughes has succeeded in wittily displaying his interest in spatial ambiguities in that the envelope appears to stand proud of the intentionally flat background.

PATRICK HUGHES
Steps and Ladders

Such graphic simplicity linked with a clever idea is typical of knife-cut screenprints. This image was created with cut film in six colours.

DUGGIE FIELDS
Liberty

Although this screenprint was created almost entirely with knife-cut film, the line stencil was made by the artist using Letraline and the sun sprayed with a gravity feed airgun.

RAY WILSON
Woman by the Pool

This image was produced with only four
purely knife-cut film stencils.

Negative filler stencils

T he use of filler as a stencil-making medium allows the artist to work directly on the screen, but in a negative form — that is, what is drawn or painted is the opposite of what will print. A simple example of this may be seen by printing an open rectangle of color and then applying some brush marks with blue filler. When the second color is printed, the brush marks appear as the base color.

A wide variety of textures and styles can be achieved by using brushes, cardboard squeegees, sponge or fabrics to apply the filler. If a stencil is already in existence, some areas may be softened by applying filler one or more of these ways. If large areas need to be filled or sharp edges are wanted, this can be achieved by squeegeeing filler across the screen, masking the areas not to be filled to produce hard edges. Since it can be extensively thinned, filler may also be sprayed, bearing in mind that the dots will be negative. Sprayed filler should be gradually built up on the screen. If the spray is very fine, it should be applied to the underside of the screen to prevent the squeegee from scraping off the particles of filler when printing. A sprayed filler stencil requires a relatively fine mesh; about 62T is the minimum mesh count, although for fine spray work 90T is required.

If oil-based inks are being used, cellulose filler can be used to produce a stencil that is the negative of the image being printed. This is achieved by squeegeeing the filler across the screen from which the ink has been cleaned. When the filler is dry, the original stencil is removed with water, leaving cellulose in the mesh.

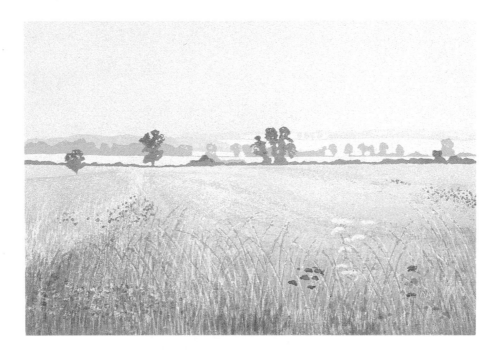

MICHAEL CARLO
Summer Evening

Artists often use filler as part of the
stencil-making process but Michael Carlo
is one of the few who use filler alone.

NEGATIVE FILLER PRINT

Bruce McLean is an artist whose work readily translates into screenprints; he uses the medium extensively for editions and monoprints. He was asked to make a print in a single day using filler to make the stencil. This technique appealed to Bruce, since stencils made in this way can provide a faithful reflection of the artist's marks, enabling the prints to have the immediacy of paintings. He is concerned for his prints to be honest in their execution; if a yellow appears to be on top of black, he will want to print it that way, rather than using the yellow as an underprint, and removing it from the black stencil. Bruce conceived the print *Eye Aye* to exploit the immediacy of this method. He found the filler too stiff to use to his satisfaction on the red printer, but by thinning it, he achieved better results on subsequent stencils.

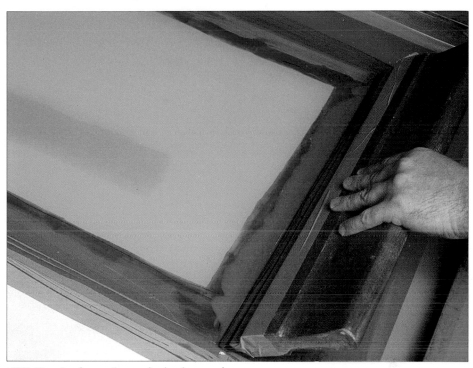

1 For the first color — the background green — Bruce McLean used a clear screen edged with blue filler.

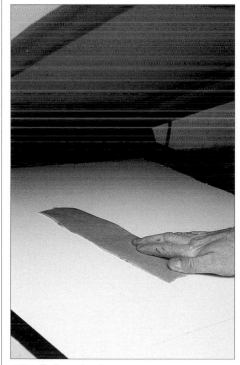

2 Before the first pull, he places a piece of torn newsprint on the paper to create a white area in the background. This is stuck to the screen by the ink during the first pull.

3 Bruce paints his next stencil on to the screen using blue filler. The positive image on the screen will print as a negative.

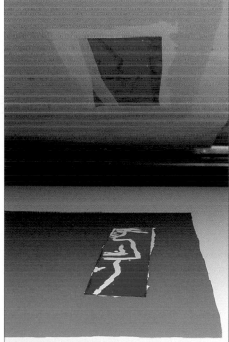

4 The underside of the screen was masked with newsprint, leaving open only the area to be printed. The red therefore appears only on those areas unmasked by paper or stencil.

Continued overleaf

Continued from previous page

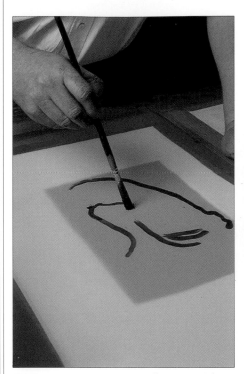

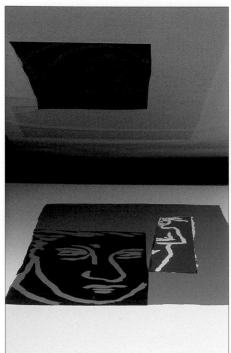

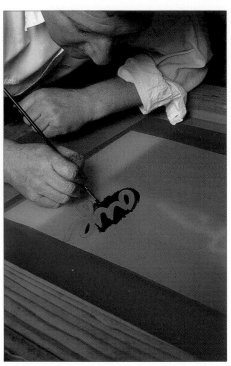

5 Bruce paints a second image with blue filler. This will also print as a negative.

6 Before printing with black ink, the screen was again masked with newsprint, leaving open a rectangle around the stencil.

7 As Bruce wishes to print positive lettering, he has to work negatively with blue filler, painting out the areas that should not print. The outlines of the letters were first drawn on to the screen as a guide.

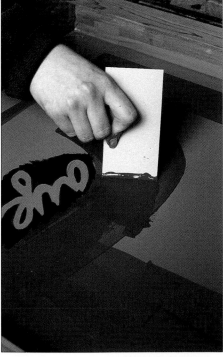

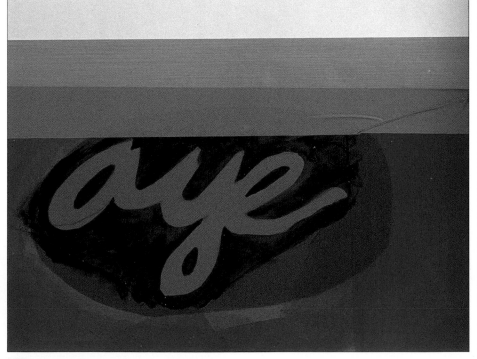

8 The lettering completed, the rest of the screen is masked out with red "flash dry" filler.

9 Since only a small area of the screen is to be printed, the remaining areas are masked on the top (printing surface) with poster paper. This reduces time spent cleaning the screen.

4

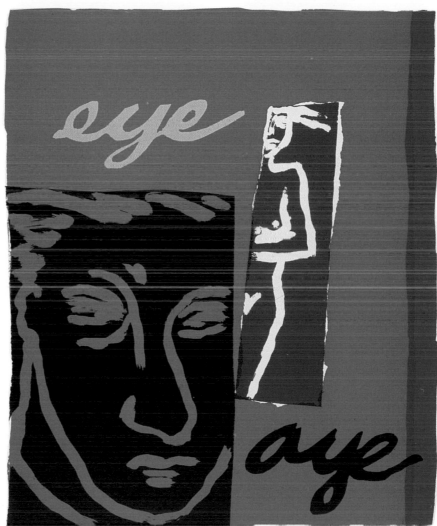

Bruce McLean: stage proofs
In the first (green) printer (1)
note the white area achieved
by papering the screen (see
step 2). In the second (red)
printer (2) the artist was not
happy with the negative image
produced by the blue filler: he
felt it was clumsy. In the third
(black) printer (3) the artist
was happier with the quality
of the new stencil painted
using thinned filler. The fourth
(black) printer (4). In a
commercial edition this stage
would have been combined
with the previous black
printing. The finished print
(5). Yellow was the final color
to be printed.

BRUCE McLEAN
Aye Eye

The finished print provides a good
example of the graphic wit of this artist.

MICHAEL CARLO
End of Harvest

This artist uses only filler to make his stencils. On a single screen which is left in constant register on the bench, he works from light to dark, gradually adding fine lines of filler until only the darkest areas remain to be printed.

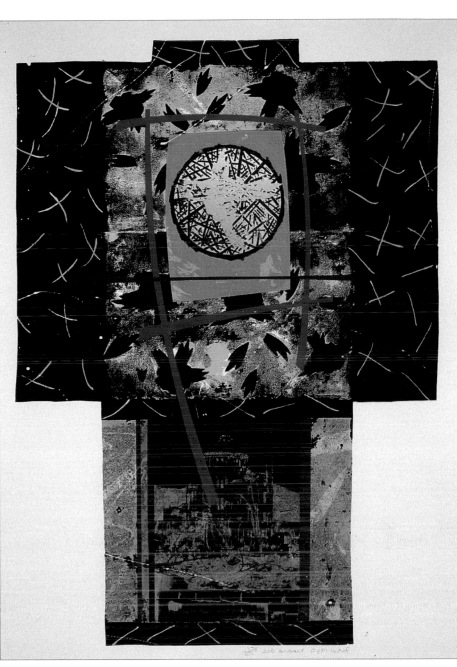

ANITA FORD
Kimono

Here filler has been used as a medium for
adjusting cut and torn stencils.

Gum and tusche stencils

This technique enables the artist to work by hand directly on to the screen to produce an image that will print as it was drawn — positively. At its best, it faithfully reproduces the subtleties of the artist's original marks as they were made on the mesh. Unfortunately it often fails to work satisfactorily. Modern fabrics are less sympathetic to this technique than is silk; they are too smooth to enable detail to be held, whereas silk has small filaments projecting from it. The best results are achieved by using traditional gum arabic or tusche stencil filler rather than the more modern fillers. These fillers are designed to resist the influence of solvents therefore they do not always leave an open screen after the tusche has been cleaned off.

The gum and tusche method benefits from a properly degreased mesh, so it is important that extraneous grease or oil is not inadvertently transferred from the artist's fingers to the mesh. If an artist wishes to trace from an original drawing or painting, the mesh should be protected with a sheet of transparent film. The screen should also be raised slightly so that the mesh does not touch the film, causing the tusche or ink to stick to it, thereby spoiling the stencil.

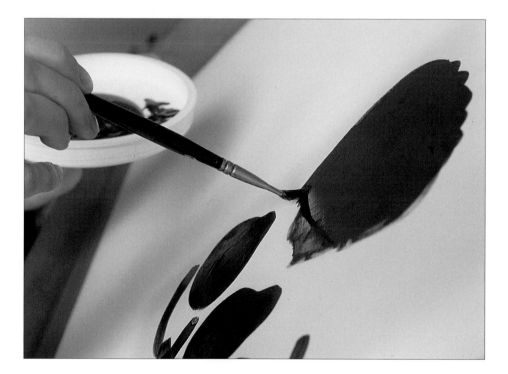

Gum and tusche

A traditional method that allows the artist to work directly on the screen creating an image that will print as painted or drawn.

GUM AND TUSCHE PRINT

Chloë Cheese, whose work relies on the quality of her drawing, was persuaded to use this technique. She was slightly reluctant, as all her previous attempts at using it in the studio had failed. However, this time traditional materials were used and the resulting print proved to be very successful. As there is a certain element of unpredictability in the technique, Chloë thinks that when working this way, it is necessary to be flexible and make adjustments as the print develops. Chloë's approach to screenprinting differs from that which she uses when making a lithograph in that she emphasizes the color element, usually using two versions of each color printed.

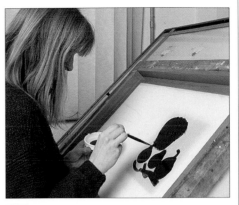

1 Having made a tracing of her original watercolor, Chloë Cheese paints the areas she wishes to appear in yellow with tusche. The blue background has already been printed using a blue filler negative stencil to mask the areas that should remain white.

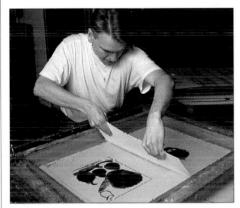

2 The printer applies gum arabic glue to the underside of the screen with a cardboard squeegee. The first coat is allowed to dry before applying the second coat. Note that two stencils have been placed on the same screen for economy.

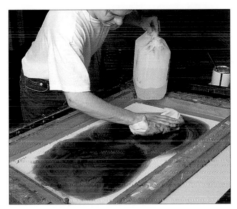

3 The printer removes the tusche from the screen with solvent or oil or spirit-based cleaner.

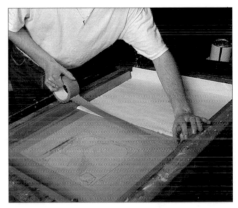

4 The stencil on the side that is not to print is masked with paper.

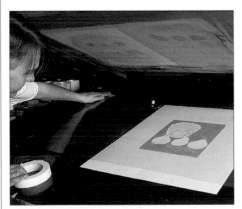

5 The blue and yellow have been printed. The printer places a transparent register sheet over the print.

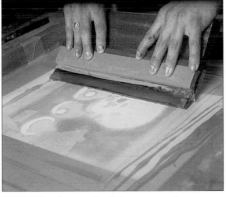

6 The first pull of the next color (orange) is printed on the register sheet to enable final registration adjustments to be made before continuing to print.

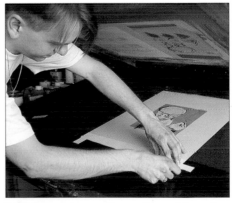

7 The printer adjusts the position of the print under the register sheet for the black printing.

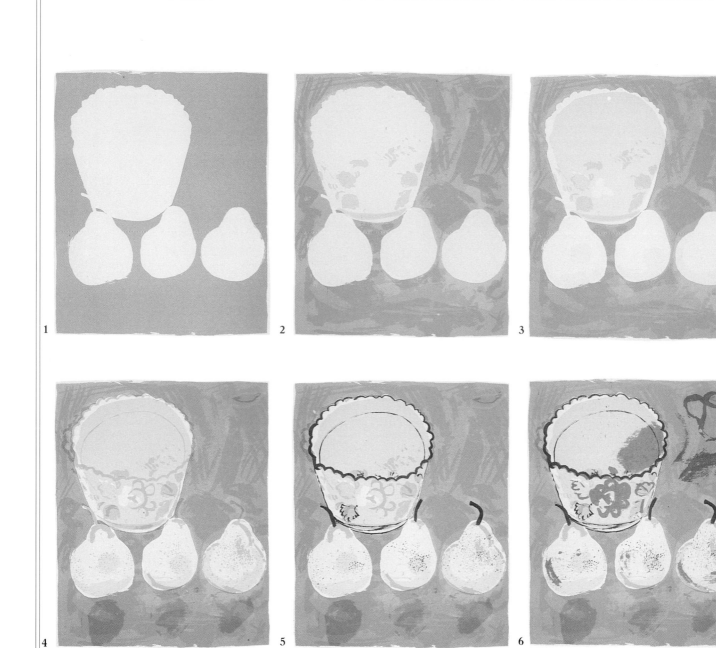

The gum and tusche method allows Chloë Cheese to build up the subtle colors in her image gradually. The first stencil produces the background blue. The edges, bowl and pears were masked with filler (1). The same screen was painted with tusche and reprinted with blue to bring out the background texture. The screen was cleaned and negative areas painted with tusche and printed with yellow (2). A blend of yellow was printed from left to right making the color darker at the top (3). Details were painted with tusche using a brush and pen and then printed in sequence with pale brown (4), rich brown (5), and red (6).

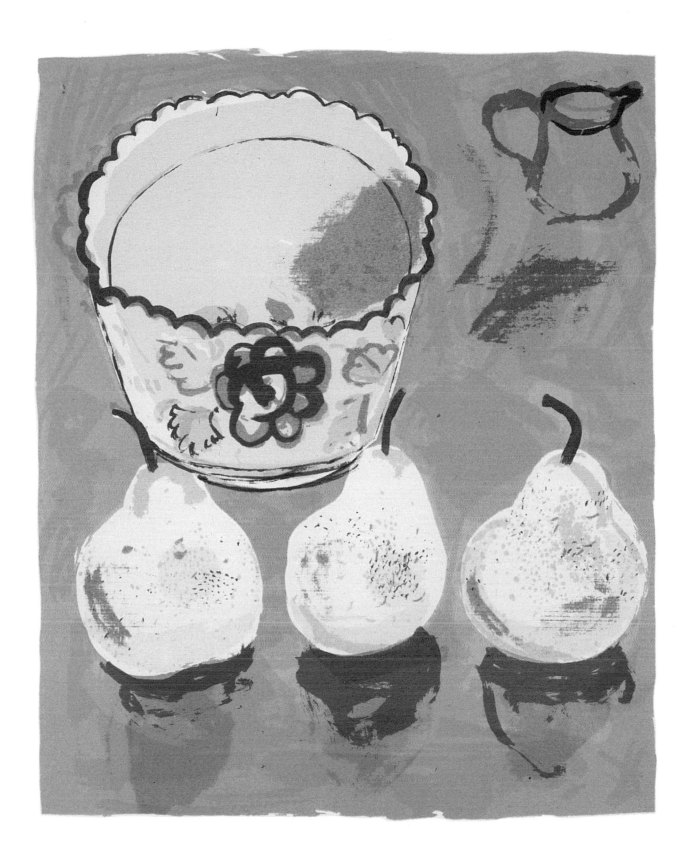

CHLOË CHEESE
Yellow Bowl

A successful result due mainly to the
artist's delicate approach to her work.
Gum and tusche can be difficult to work
with and its unpredictability does not suit
all artists.

BRAD FAINE

The stencils for the center panel of this print were made with gum and tusche.

CHLOË CHEESE
Spice Chest with Coriander

The first screenprint published by this
sensitive artist, it is made entirely with
autographic stencils using gum and tusche
in the background areas.

Autographic positive stencils

T he autographic positive stencil allows the artist to draw or paint directly on sheets of tracing film or specially-manufactured transparent planning foils that have been treated to accept water-based paint or photographic opaque. Each color is drawn on to a separate sheet of film, although it is possible to put two colors on a single sheet if small areas of color are being used. Using this type of stencil material, the artist can produce hand-drawn or painted images because the marks that the artist makes will be transferred to the photostencil film to create a positive stencil. Being such a direct method, it is simple to understand and can also produce complex and beautiful images. It also provides the means by which textures or soft-edged images can be made into stencils.

The paint or ink used for making an autographic positive stencil does not have to be visually opaque, but must resist the passage of ultraviolet light. It can therefore be amber or red safe transparent color. The advantage of this type of pigment is that it is possible to work on one sheet of film which is placed in register over another, already completed, and still see the image underneath.

The autographic positive stencil is a descendant of the serigraph, where the stencils were produced directly on the screen by the artist. This technique provides a continuation of that tradition, with the added luxury of being able to produce finer detail using modern materials and without the fear of the stencil deteriorating as it is printed.

The scope of this technique ranges from the solid line images of an artist like Duggie Fields and the ethereal drawing of Adrian George, to the variations of brushmarks to be found on canvas, the continuous tone effect of hand-sprayed stencils by Brendan Neiland or Ben Johnson, the use of texture in frottage, and the amalgamation of all these elements with everyday materials to produce collage stencils.

NORMAN STEVENS
Crathes Castle Garden

The artist gradually built up the color and tone in this image with a series of autographic positive stencils. These were individually painted with black opaque ink by the artist on to the superimposed sheets of transparent film.

AUTOGRAPHIC DRAWN STENCIL

Jean Stevens gave her permission for the use in this book of *Black Walnut Tree 1987,* an autographic screenprint by her late husband Norman Stevens made to commemorate a devastating storm in October, 1987, when hundreds of thousands of trees in southern England were destroyed in one evening. The print, which was commercially sponsored, was part of the effort to raise money to replace the trees and shrubs in the Royal Botanic Gardens at Kew, London that had been destroyed by the gales.

Norman Stevens had a particular affection for a large black walnut tree, which the storm had sadly uprooted and which was subsequently sawn up. He said at the time, "It was terrible to see what had happened to the gardens, but when it is all cleared up and turfed over, the people may wonder what all the fuss was about, perhaps Black Walnut will help them to remember." Norman drew the separations for the print using black opaque ink with brushes, sponges or fabric for stippling, and a toothbrush for splattering.

Norman Stevens: color print-outs
These color print-outs of a small section of the numerous autographic stencils made by the artist for this screenprint show the progression of colors used (see page 101). The order in which colors are printed is determined by the print itself and what is necessary to make adjustments as it progresses. The progressive print of this section, a combination of these first five printings, shows how the print would look at the half-way stage.

Continued overleaf

Continued from previous page

6

7

8

9

10

11

Norman Stevens: color print-outs continued

Above The next six stages of the printing show how the color range and tone of the half-way image is further built up with sensitive touches of color. The artist in mixing these colors uses inks with different characteristics — transparent, opaque and translucent — to produce a wide range of effects in the final print.

Right The combination of these six print-outs with the five before can be seen in this detail of the print. The artist succeeds in achieving a depth of tone and color which bears witness to his mastery of the medium.

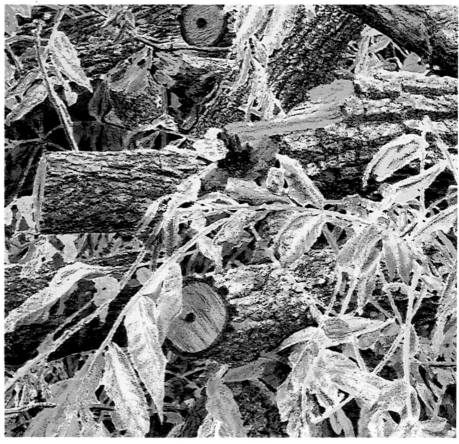

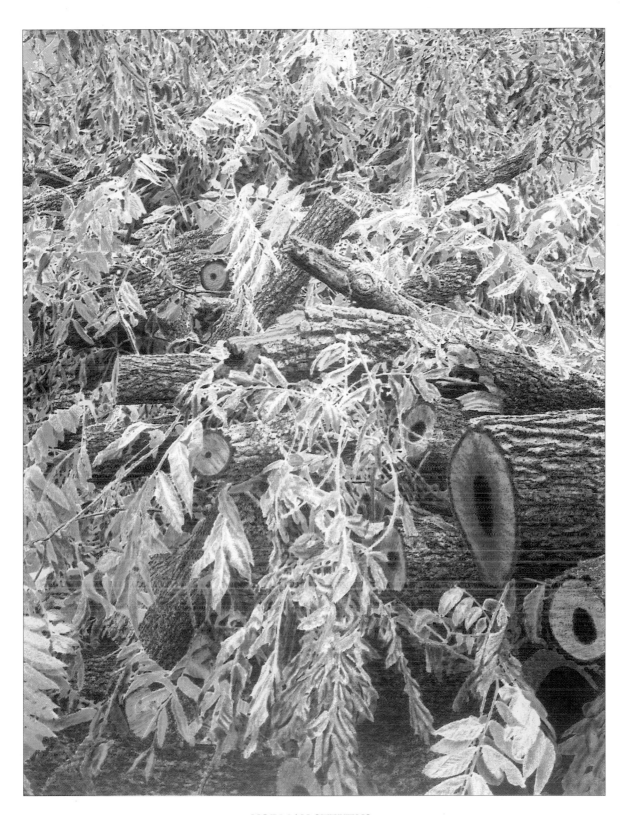

NORMAN STEVENS
Black Walnut Tree, Kew Gardens
21st of October 1987

Portraying the ravages of the Great Storm
on the botanical gardens at Kew in
London, this accomplished screenprint
was completed just before the death of
Norman Stevens in 1988.

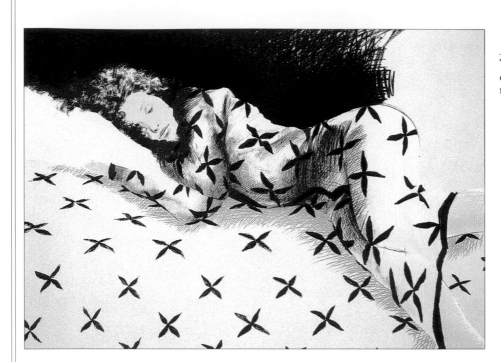

ADRIAN GEORGE
Belle de Jour

The grainy effect of this print was contrived by drawing each stencil on textured tracing film.

TONY ANSELL
Winter Landscape

By drawing on to sheets of tracing film with soft black crayon, the artist was able to reproduce the texture he envisaged for this image.

ANDREW HOLMES
American

The texture in this sophisticated
autographic screenprint has been achieved
by spraying on to the drawn stencil.

CONTINUOUS TONE POSITIVES

In screenprinting, continuous tone or any tonal gradation is the result of producing regular or irregular dots or marks on the stencil to create the illusion of tone transition. One way of doing this is to use pen and ink to produce handmade dots which by their frequency differentiate the areas of tone. There are a number of other ways to achieve a continuous tone effect — for example, by using black crayon on textured tracing film or even by drawing on thin tracing film over different grades of sandpaper and textured watercolor paper, as done by Adrian George. The forerunner of the spray-gun technique uses a firm bristle brush or a toothbrush to splatter ink or paint on the stencil positive, to produce different tonal qualities and textures. Tone can also be added to a stencil by stippling thick black paint with a sponge, muslin, absorbent cotton, or any other material with a distinct surface texture that will transfer to the stencil (for example, velvet). This latter method can also be used to apply areas of tone directly to the screen if filler is substituted for ink.

DAVID LEWIS
Les Palmes — Nice

To reproduce the effect of a pastel drawing the artist drew with a waxy crayon on to thin tracing film placed over a sheet of watercolor paper. The texture of the paper was picked up by the crayon breaking up the stroke.

ADRIAN GEORGE
In Violet

Here the artist produced a stencil for each color by drawing on to a specialist keyed film with a soft black crayon.

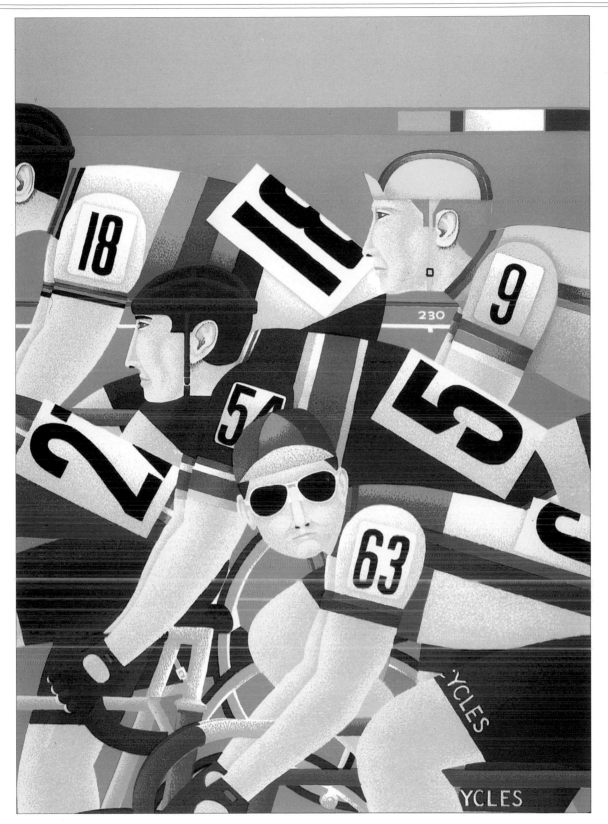

REG CARTWRIGHT
The Cyclists

Each tonal stencil for this screenprint was
made by the artist using a Rotring pen. In
this way dots were laboriously applied to
the stencil and built up to the density
required.

FROTTAGE POSITIVES

Frottage positives are made by taking a rubbing of a texture from an attractive surface such as wood, and using it to produce a textured form, which can then be transferred to the screen using a photostencil. It can be a very useful technique if a number of different surface qualities are needed. The best material on to which to take the rubbing is thin tracing film. Any black opaque crayon or rubbing wax can be used to transfer the image. It is a good idea to make the rubbing slightly darker than is actually wanted as there is usually some loss of detail when the rubbing is made into a stencil. It is possible to make a rubbing directly onto a screen with a greasy crayon, and then process it as for the gum and tusche method. If this method is attempted, care must be taken to avoid damage to the mesh.

MICHAEL HEINDORFF
Tasso's Trees (one of a set of 14 prints)

The figure-like tree trunks here are confirmed in their arboreal status with the use of the frottage technique. By rubbing tracing film placed over a piece of pine with a waxy crayon the texture is quickly picked up.

BRAD FAINE
The center section of this print of metallic primary colors was the result of frottaging various surfaces located around the studio.

MICHAEL HEINDORFF
Tasso's Trees (one of a set of 14 prints)

The broken color of the frame which has
the appearance of a scumble was the
result of printing yellow frottaged
woodgrain over a deeper red/orange base.

BRUSH MADE POSITIVES

All types of brushwork are capable of being translated into a positive stencil: thin painted lines can be reproduced as easily as broad brush strokes; the treble 0 brush may be used alongside the paint-roller. The only limitation is the technique of the artist.

To reproduce successfully on a stencil, brush marks must be painted on a suitable translucent or transparent material in paint or ink that is opaque to ultraviolet light. To ensure that the subtlety and detail of the marks are maintained, the medium used should not be too thin — black gouache and thinned screenprinting ink are ideal. This technique can also be used to apply brush marks directly to the screen using filler to develop or adjust the stencil.

NORMAN STEVENS
Laurel Tree, Nettlecombe Court

Each stencil was separately drawn, painted and stippled by the artist, building up to this light-filled scene.

FRASER TAYLOR
Crouching Figure

Each color in this screenprint was painted by the artist in broad brushstrokes on to sheets of tracing film so that the brushmarks determined their own forms.

COLLAGED AUTOGRAPHIC POSITIVES

Any opaque image on a transparent background can be combined on the same stencil with any other similarly opaque image irrespective of how each image was produced. Brushed stencils can be combined with frottage, drawing with spraying — the number of possible permutations is huge. If an object is opaque enough, it can be used as a positive and can be printed. A simple example may be seen if a paper doily is painted with black ink and used to prevent light falling on the stencil material. Fabrics can be dyed to be used as positives and pieces of wood or interesting surfaces can be rolled with black lino ink and contact printed on to transparent material to produce direct positive materials. Torn black paper stuck on to film provides an alternative to the conventional paper system with the added advantage that it can be combined with other autographic and/or photographic techniques.

IVOR ABRAHAMS
Vahine 1 and 2

The point of departure for these two images was figures found in a magazine. These were reduced and abstracted by various methods (including photocopying) and used as a positive. Hand-worked textures were printed over this to enhance the image.

HAND SPRAYED POSITIVES

Spraying on to stencil film with ink or paint using a spray gun is an ideal way of producing different areas of tone, as the darkness or lightness of an area can be determined by the amount of ink which is sprayed on the positive. The best spray gun for this purpose is of the gravity-feed type as it operates using a minimum of pressure, which enables the artist to produce large enough dots for reproduction (a high-pressure spray produces smaller dots). Alternatively, a mouth-blown diffuser can be used.

It is advisable to experiment with different inks or paints to find a medium that will spray well and be opaque enough to resist the ultraviolet light source. Black indian ink is often successful, as is orange masking fluid, which enables the artist to see a completed positive beneath the one that is being worked. Filler can also be sprayed directly onto the screen, but remember that it produces a negative.

A sprayed stencil almost invariably requires some sort of masking. A variety of masking materials can be used, including masking tape and paper, cardboard stencils, air-brush film or book covering film that has been dusted with talc, and, if difficult curves or complicated areas of texture are wanted, art masking fluid or even cow gum could be used. The closeness of the mask to the positive determines the sharpness of the edge.

BRENDAN NEILAND
Winter Landscape

Using paper masks loosely placed over tracing film, the artist sprays each area of color to create soft shapes.

BEN JOHNSON
Renault Centre

Six photostrip stencils were produced
from an accurate line drawing by the
artist. Each stencil was then hand sprayed.

BEN JOHNSON
Renault Centre

Six photostrip stencils were produced
from an accurate line drawing by the
artist. Each stencil was then hand sprayed.

Photographic positive stencils

T he application of photography to the making of positives for use with photostencil materials has enabled artists to convert photographs into prints and to integrate handmade and photographic positives on the same print. It is often said that the use of photography has had a detrimental effect on printmaking. However, it has provided a vast supply of material from which images can be made. Prints can be made by using photography directly as in Andy Warhol's *Campbell Soup Cans,* or by posterizing the image by under- and over-exposing a negative as in the case of the classic Gerd Winner prints made at the Kelpra Studio in the 1960s. The image can also be manipulated at source. Jack Miller used the services of a photocomposition laboratory to assemble without any visible seams two separate transparencies shot on different locations to produce the prints *Frolics Motel* and *Sunset Cadillac,* while Boyd and Evans collaged pieces of different photographs to make the print *Passing Through.* In the case of photography the medium provides a dictionary for the message.

Photography also provides a way of generating stencils from original artwork, if the artist wishes to approximate a particular quality not easily produced by other stencil techniques, for example, watercolor washes. This sort of quality can be produced by under- and over-exposing different sheets of line film to provide a range of tones, by introducing a photomechanical screen such as a half-tone, mezzotint or special effect soft screen between the film in the enlarger and the film to be exposed. Alternatively, a similar effect can be produced by increasing the grain size of the original negative or transparency by copying it on to recording film and then enlarging the result on lith film.

It is rarely the case that individual colors can be separated photomechanically; most scanners only separate variations of the four-color process system. Although it is possible to separate red from blue or green, colors are not specifically identified, so they will only reproduce exactly if the artist is using the four color process inks. If an artist wishes to use a more subtle range of colors, then the photographic process will have to be assisted by hand-working the positives before they are exposed on to the photostencil film.

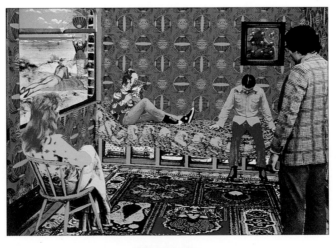

TIM MARA
Alan's Room

The photopositive for this image was
underprinted with separate handmade
colors and then masked out to allow the
different areas to be printed.

LINE FILM PHOTOPOSITIVE

Ilana Richardson is an artist who enjoys working with film and manipulating it to achieve exactly what she wants from it. In the example used in this project, the studio tone-separated 12 full-size negatives from her original watercolor painting and contact printed them to produce positives. The advantage of working with full-size negatives is that they can be conveniently hand-worked. If further separations are needed, these can be contact printed without having to photograph the original again and the new positives accurately match the size of the existing ones.

Ilana manipulates each positive by cutting up and rearranging the various elements on the film and then hand works it to enhance or clarify a particular area of color. As the separations are predominantly tonal, the color has to be introduced by hand and carefully proofed to obtain a balance between the photographic tone and the integrated color. Ilana uses only transparent colors, so the print maintains the freshness and luminosity of the original watercolor.

1 Ilana adds some pieces of cut up photographic positive to the main dark tone positive to bring out detail in that area.

2 She works on the positive further with a brush and photographic opaque to add areas of color where the photographic separation process has failed to differentiate paler details.

Continued overleaf

Continued from previous page

3 Having mixed up sufficient ink to print the full edition, Ilana checks the color against the original watercolor.

4 Meanwhile, the printer prepares the screen prior to printing. Note the masking of the underside of the screen to prevent spots of ink from appearing on the edges of the paper if there is any breakdown of the filler during the course of editioning.

5 Instead of inking the whole screen, the printer initially prints only a small area of the screen to test the color on a proof. If the color is not quite right, it is necessary to clean only a small area of the screen. Inset: A close-up of the corner of the stencil showing the area tested.

6 Following a final check on the color quality, the edition can be printed.

7 This is a fairly large edition — 225 prints plus proofs — so the printer uses a one-armed squeegee, as it is less tiring to use than a hand squeegee.

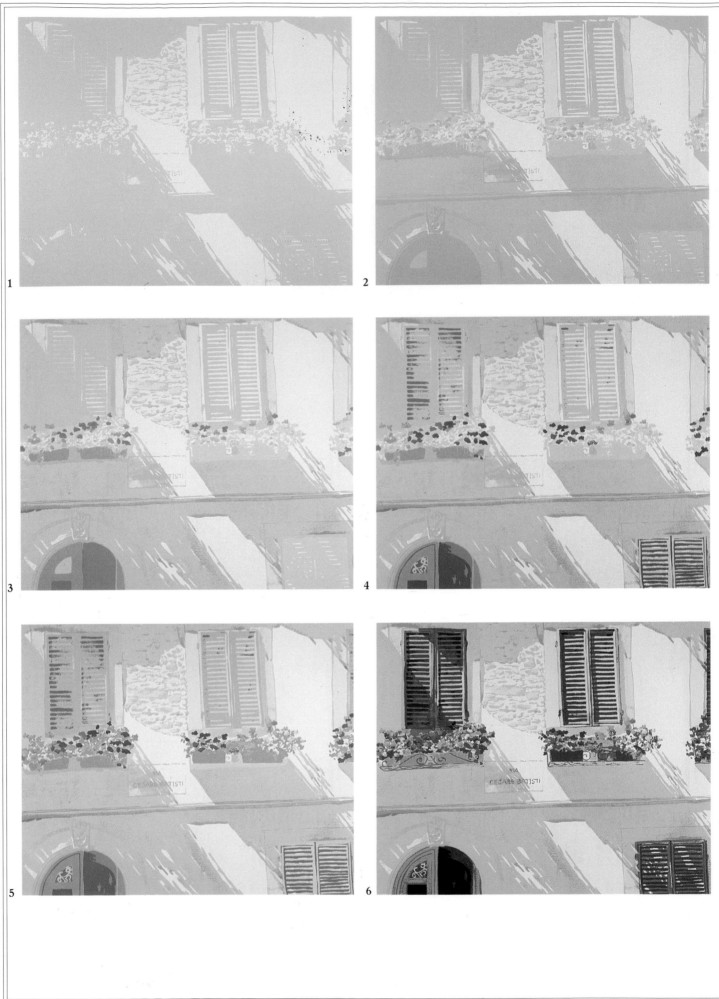

1

2

3

4

5

6

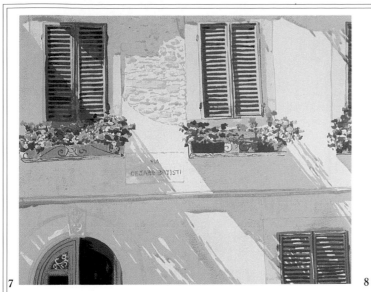

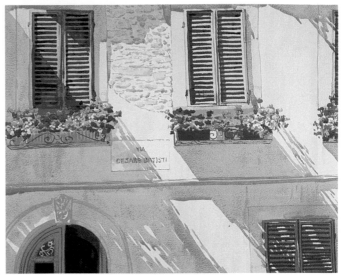

7

8

Ilana Richardson: progressive proofs
In these progressive proofs it is possible to witness the gradual build-up of color effected with transparent inks to preserve the luminosity of the original watercolor painting. Note how the artist prints a mid-tone stencil to start with to provide a readable registration key for the very pale colors. This is not, however, included in the progressives.

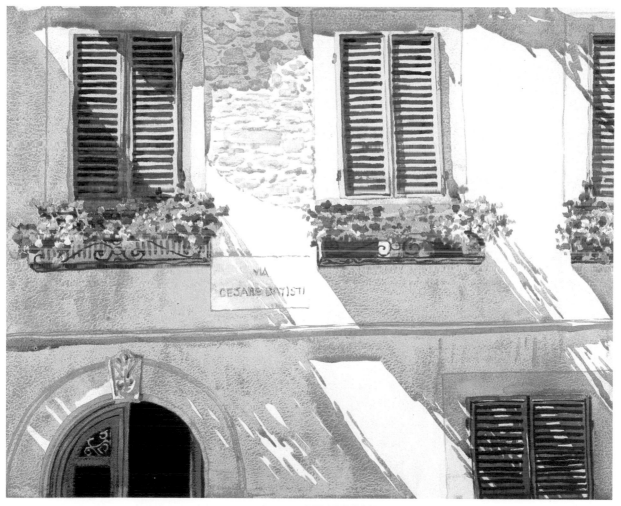

ILANA RICHARDSON
Via Cesare Batisti

As a result of the artist's attention to detail, the final screenprint retains all the atmosphere and light of the original.

HALF-TONE PHOTOPOSITIVES

Half-tones are the means by which continuous tone photographs are translated into printable images for newspapers, magazines and books. The illusion of tone is created by breaking up the image into a regular pattern of dots — the density of the dots in a given area determines their tonal value. A half-tone photopositive is produced by interposing a photomechanical screen between the original negative and the sheet of film on to which the image is to be transferred. The half-tone screen, which must be dust-free, is placed in close contact with the film, emulsion-to-emulsion. Although the use of half-tone in limited edition prints is somewhat restricted by legislation, notable artists have nevertheless successfully used this technique for producing screenprints.

By using large dots, Andy Warhol deliberately drew attention to his use of half-tone images in his screenprints. Other artists who have made half-tone screenprints include R.B. Kitaj, Ben Johnson and Jack Miller.

BEN JOHNSON
IBM Glazed Arcade

As well as a conventional four-color separation using half-tone screens, the artist made his own random-dot screen with a 0.25 Rotring pen.

JACK MILLER
Santa Monica Juice

A four-color separation taken from a
35mm transparency over which hand-
made stencils have been added including
the pearlized pink for the car.

MEZZOTINT PHOTOPOSITIVES

Like half-tones, mezzotints break up continuous tone images into gradated tonal images that are capable of being printed. However, in mezzotints the dot pattern produced on the positive is irregular. Mezzotints can be made in the same way as half-tones using commercially-produced screens that are available in a wide range of textures. However, because the dot is irregular, mezzotints can also be produced by hand by spraying directly on to the film and screen-produced images can also be reworked with a spray gun. Another way of producing a mezzotint is to enlarge the grain of the photographic film. This last method was used to create the prints shown on this page by Ben Johnson, Harry Thrubron and Sylvia Edwards.

BEN JOHNSON
Greek Window

This image was made from a transparency enlarged to grainy black and white negative film that was processed to increase the grain size. Color was added with handmade stencils.

HARRY THUBRON
Jacob

Each element was individually photographed and hand separated and then the grain of the film enlarged to produce a mezzotint.

SYLVIA EDWARDS
Creature's Home

The watercolor quality of this screenprint
was achieved by interposing a custom-
made mezzotint screen between the film
and the original. The colors were then
added with handcut stencils.

COMBINED PHOTOGRAPHIC IMAGES

There are many ways of combining photographic elements to create a new photographic image on which to base a photostencil. Elements from photographic prints can be assembled to create a new artwork that is then re-photographed. *Passing Through* by Boyd and Evans is an example of this technique. Alternatively, the photographic elements can be taken from different transparencies and combined to produce the new composite image without visible joins. This technique is known as photocomposition. Examples of the use of photocomposition include *Frolics Motel* and *Sunset Cadillac*, both by Jack Miller.

JACK MILROY
Flowers

The artist has assembled various diverse elements — some woodgraining, a piece of wallpaper and a photographic print — to make this print. These were individually photographed and then combined to make the screenprint. Note the use of high-gloss ink to create the finish on the photograph.

JACK MILLER
Frolics Motel

Individual elements from a number of transparencies were combined in a photo-composition studio to produce the single color transparency from which this screenprint was made.

BOYD AND EVANS
Passing Through

A photomontage created from assembled photographic elements with four-color separation in the foreground. The sky color was applied as a blend and there are hand-worked areas.

CONSTRUCTED OBJECTS

One advantage of using photographic images is that an object which is basically three-dimensional can be reduced to a two-dimensional negative and with the use of line or half-tone be integrated into a print. An example of this may be seen on the print by Patrick Hughes *Paper Roses,* where the mass of roses were made by covering a large wooden former with hundreds of plastic flowers that were then photographed on to slide film and separated so that the colored flowers all appeared as shades of red.

PATRICK HUGHES
Paper Roses

The appeal of this image is in the conflict between the three-dimensionality of the roses and their graphic two-dimensional surroundings. Hundreds of plastic roses were fixed on to a wooden former and photographed. The color was then separated and printed in different tints of red.

PATRICK HUGHES
Stardust

Using the same idea, this time hundreds of stars were stuck onto a black former before being photographed — hence the perfect perspective of the stars on the receding surface.

EXPERIMENTATION

The darkroom provides numerous possibilities for photographic experimentation — for example, with chemicals to alter the nature of film, by making further exposures in which new images are introduced or filters are used, or even by drawing or scratching on negatives and transparencies.

COZETTE DE CHARMOY
Five Reliquaries (one of a set of five prints)

Screenprinting using photographic processes offers plenty of opportunities for experimentation. Here the artist has combined various photographic techniques — mezzotint, four-color separation printed in reduced colors for the foreground, a fine half-tone for the photograph with a high glaze printed over the top, and conventional line imagery above.

Part Six

THE FINISHED PRINT

With the creative and printing process completed, the artist must
turn his thoughts to finishing and signing the print as well as the
all-important aspect of costing and selling it.

Finishing techniques

When the printing of an edition is finished, you will need to consider whether or not to apply any sort of finishing process. There are a number that can be used in the home or college print studio, but others require the facilities of a commercial studio or "print finisher." The most useful of the screenprinted finishing materials involve different types of glue which can be overprinted so that flocking, gold leaf, glitter particles or collage can be applied to the print.

FLOCKING

In order to flock an image, gum is printed through a spirit-based stencil. While this is still wet, quantities of tiny nylon filaments are applied with a hand-held gun. Flock is made of short, accurately cut nylon fibers. These are available in lengths of 0.5mm to 4mm in many different colors. The flock is stored in a hopper on the gun and fed through a metal grid which electrostatically charges the fibers, causing them to embed themselves end-on in the glue, creating a surface rather like the pile of a carpet.

GOLD LEAF

Gold leaf can also be applied by printing gum or gold size through stencils. Gold leaf — either real gold or a cheaper alloy — is produced in sheets 6×6in, which are so thin that a half-inch cube when rolled out produces an area equivalent to a soccer field. Gold leaf is so delicate that it can be destroyed merely by blowing hard on a sheet. Apply the gold leaf with a soft brush by laying it on the printed area of gold size before finally burnishing it. Once the gold has been applied, the same stencil that printed the gold size is used to apply a sealing varnish to prevent it from oxidizing and discoloring. Transfer gold leaf, which is easier to handle, is available. The transfer is laid on to the gold size and the backing paper peeled off.

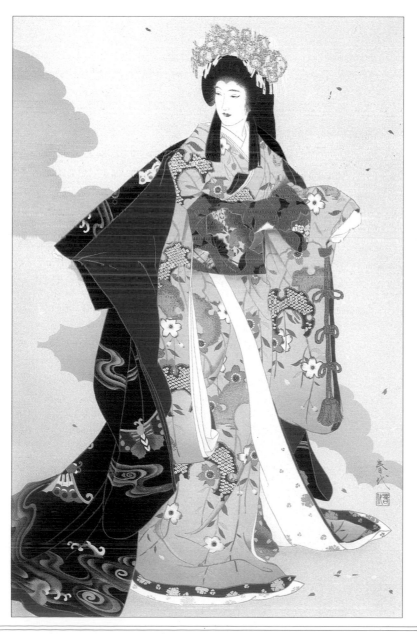

HARUYO
Princess Sakura

Japanese pigments were used for special effect and glitter inks added to heighten areas of gold and silver on the traditional Japanese kimono design.

GUM-BACKED PRINTS

Three-dimensional and collaged prints can be assembled by printing the image in gum on the reverse side of a print. When an area has been conventionally printed and dried, the printed image can be turned over and printed on the back with gum. When the gum has become tacky, it is covered with silicon paper to enable it to be handled. The printed image can then be cut out and assembled on another print by peeling off the silicon paper and exposing the gummed area. In this way three-dimensional or collaged prints can be assembled, using different sorts of papers or boards to vary the surface quality of the image.

FOIL BLOCKING

Hot-foil gold and silver blocking has to be professionally applied as it requires specialized equipment. Foil blocking enables mirror-like areas to be applied to the finished prints — an effect that is very popular in the United States. The problem with hot-foil blocking is that many prints are spoilt by registration difficulties and it is not easy to make sure that the foil bonds. Consequently, when using this process, it is advisable to print about one and a half times the required edition size to allow for wastage.

EMBOSSING

Embossing is a technique whereby a relief pattern can be impressed into or pushed out from the surface of the paper.

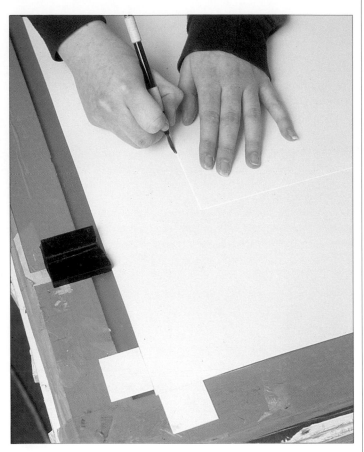

Hand embossing
The raised "former" is held in place underneath with double-sided tape while the embossing tool is run around the edge (**above**). The finished embossed edge (**left**).

Sylvia Edwards

Embossing can be used most effectively to delineate the edge of a print where the image is irregular. Embossing can be accomplished fairly easily in the home studio by cutting a "former" from thin plastic or cardboard in the shape of the area to be embossed and sticking this to a drawing board or light table. If the image is to be indented, the former should be positive, if the image is to be pushed out, it should be negative. Registration is effected by means of lays in the same way as when editioning (see page 64), but with the printed image side down. The embossing is carried out by hand by carefully running an embossing tool, made of bone or shiny metal, around the raised former, thereby distorting the paper. The depth of the embossed image depends upon its outline — angles and corners should not be embossed deeper than about $\frac{1}{16}$in, curves and softer edges can be embossed to about $\frac{1}{8}$in.

EXPRESSIVE HAND-FINISHING

The monoprint approach can be extended to the limited or indeed unlimited edition by the artist hand-working elements of the image — for example, by using paper stencils and registation keys to apply paint or spray directly on to each print. Alternatively, the artist can work quite freely, registering from the print itself — for example, when painting directly on to a print or aligning contact printing to vary the qualities of the surface.

If oil or wax crayons are used to draw directly on to the mesh, a number of colored areas can be simultaneously printed (rather like the colors on an etching plate) by charging the screen with either transparent base or a transparent ink and squeegeeing it through the mesh. A number of prints can be made from each application of crayon, although each print will be paler than its predecessor.

CHRIS BATTYE
Dinner Party

This autographic print was printed with
oxidization inks six times in order to
produce a high-gloss finish.

Signing the print

With the printing and finishing completed, the next step is to check the quality, clean up and then sign the edition.

QUALITY CONTROL

Checking the quality of your prints can be depressing work because there are always minor mistakes which are part of the print-making process. At this stage they may look like glaring disasters — for example, spots and finger-marks on the paper borders of the print. Such marks usually can be easily removed from sized and "NOT" surfaced paper, but it is more difficult with hot-pressed or coated paper. The recom-mended technique for removing these marks is to apply invis-ible tape carefully to the mark and then remove it, lifting the ink from the surface of the paper. Repair any paper damage by burnishing the surface with a clean, shiny metal tool. Larger areas can be cleaned up with clean flour-paper, again followed by burnishing once the ink has been removed.

Prints can also be returned to a pristine state after being handled many times by rubbing the paper with a "magic" pad — a cotton fabric bag containing powdered resin. This removes all traces of dirt and dust. If an eraser needs to be used on a print due to mis-numbering or incorrect spelling of the title, it should be the kneaded putty type.

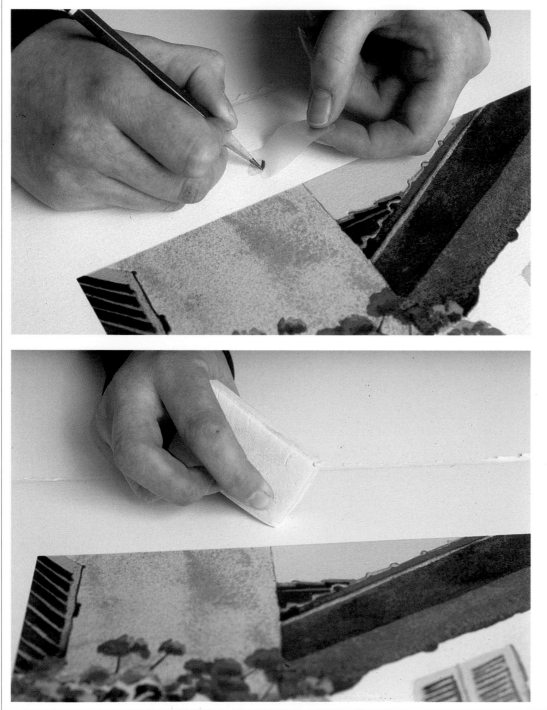

Removing marks with tape
Invisible tape is the best way to remove spots of ink from paper. Apply the tape gently and lift it off again. Hopefully, the mark will come away. Repeat this action with a clean area of tape if not entirely successful the first time. If the mark still lingers, try applying pressure to the area covered with the tape by pressing the tape lightly with a pencil before lifting it.

Removing marks with a kneaded rubber eraser
The eraser can be kneaded into any shape required. It is soft and can be used to remove dirty spots and finger marks on the border of a print. If used carefully, it should not damage the surface of the paper, but if this should happen, try burnishing it carefully with a clean shiny stainless steel tool.

Signing, titling and numbering
The above detail of *Yellow Bowl* by Chloë Cheese shows the usual practice for signing, titling and numbering prints. In pencil the artist has placed her signature below the image on the right-hand side with the title in the center and the number of the print on the left-hand side. Here the artist has marked the print "AP" meaning Artist's Proof but the number of the main edition would be expressed as a fraction (for example, 5/25 means the fifth print in an edition of 25).

SIGNING PRINTS

The way an artist intends to sign a print (the size of handwriting etc) should be taken into account when deciding precisely where to put the image on the paper. It is usual for the border to be slightly deeper at the bottom of the print than at the sides and top. After all, if a print is to be signed, titled and numbered, then effectively a line of text is being added to the bottom of the image, so this should be allowed for when it is initially positioned on the paper. Another reason for offsetting the picture is that when seen vertically on a wall, a square or rectangle placed centrally on a sheet will appear to drop slightly so that it no longer appears to be in the center of the paper.

The significance and position of the signature and the number of prints were briefly explained on page 16. There are certain conventions regarding these points which can be ignored, but to which you have to conform if prints are to be sold in countries where import restrictions and state laws are strictly interpreted. Convention has it that an edition should only print 10 per cent extra artist's proofs, which should be numbered separately from the main edition. (Usually these are numbered with Roman numerals, prefixed AP or Artist's Proof.) Any other prints should be personalized so that they do not appear as edition prints. However, these should appear on the authentication certificate if there is one.

Stage or state proofs are the names given to prints that are different from the final edition, but which are necessary to the process of developing the final image. These proofs usually occur when a print is being proofed and some collectors prefer them to edition prints. The printer or studio is usually given a copy of the print by the artist. The decision whether or not to sign such a print is made either before the printing commences or at the discretion of the artist.

The number usually appears at the bottom left-hand corner of the print, just under the edge of it, the title in the center and the signature of the artist in the bottom right-hand corner. Sadly, the practice of dating prints has almost ceased, as many dealers are reluctant to exhibit last year's images. This is a pity as it makes it more difficult to trace an artist's development.

Selling prints

When it comes to costing a print, there are various factors that need to be taken into consideration, not least the artist's reputation. However, a convenient formula used by many artists to establish a retail price is to multiply the printing cost plus the artist's fee by four (for Europe) or six (for the United States). If the artist then finds that the retail price bears little relation to similar quality prints, the print costs and fee can be re-calculated accordingly. For example, if a print costs 20 per unit to make, and the artist wants a fee of 30 per unit, making a total of 50, then the retail price per unit would have to be a minimum of 300 to allow for wholesale and gallery distribution costs. If, however, the artist's work would normally sell for only 150, then a figure of 25 should be spent producing the print divided between the artist and production costs.

APPROACHING A GALLERY

The process involved in selling prints is strewn with pitfalls. First of all, you need to approach a gallery. It is advisable to check beforehand to see whether or not a gallery handles the type of work you are selling; it is a waste of time and energy to take large abstracts to a gallery specializing in nineteenth-century hunting prints.

Once a list of galleries sympathetic to your work has been drawn up, then a direct approach should be made. Remember the average gallery has between 10 and 20 unsolicited applicants each week. They are running a business, so you must be professional. It is a good idea to write or telephone for an appointment. Do not be surprised if the gallery asks you to send some slides of your work before agreeing to an appointment. If so, do not send too many slides, six to eight copies of recent work is enough. If asked to come for an interview, take only the prints that are for sale and, again, not too many. Avoid subjecting the gallery to the monotony induced by showing 10 or 20 color variations of the same image.

Sometimes artists feel that the gallery wants to take too large a percentage of the retail value of a work (this ranges from 40 to 60 per cent). Before making a judgment on this, try to determine what the gallery will invest in promoting your work, at home and abroad, in protecting the market, and in publishing future work.

SALE OR RETURN

Many galleries will suggest taking work on a sale or return (SOR) basis. Unfortunately, lesser-known artists often have little option but to accept such a proposal. It should, however, be made clear, if possible in writing, that (i) the work should be returned in the same condition as it was supplied, (ii) the SOR is for a specified period of time and (iii) that the percentage paid to the gallery should be significantly less than if the work had been purchased outright.

If prints are to be stored, they should be laid flat, with a sheet of acid-free tissue between each one. It is wise to keep them in plastic bags to protect them from dust and moisture.

Caring for your prints
The best way to store prints is to lay them flat with acid-free tissue paper between each sheet (**far left**). If you intend to store them for any length of time, place them in a plastic bag to protect them from dust and moisture. To mail a print, roll it up with the image on the outside and a sheet of acid-free tissue protecting it, and anchor with low-tack masking tape (**above**). Insert the roll carefully into a strong cardboard tube (**left**).

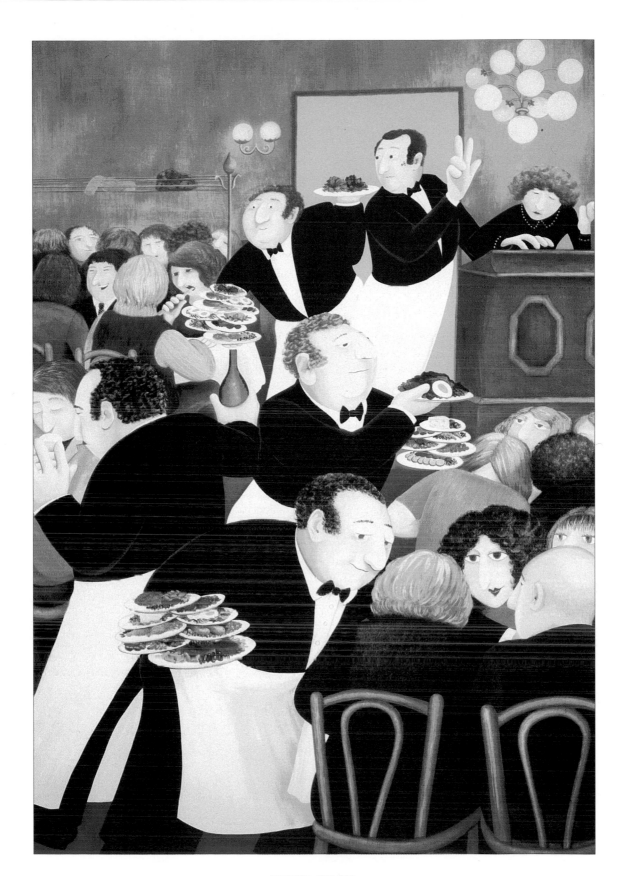

BERYL COOK
Russian Tea Room

This print, created from a combination of
photographic and handmade stencils, was
produced and printed from an original
painting, by the artist, who oversaw all
stages of its production.

Framing

It may be necessary for an artist to arrange for his own prints to be framed. The choice of frame and mat, and the placing of the image within them, can be crucial to the final impact of the print; the "right" decision enhances the image, the "wrong" one may detract from it.

When you make a print, the paper has usually been selected deliberately so that the finished work includes a border that should not be cut down for framing. This does not preclude placing a mat over this border when the print is framed, but it does indicate the minimum size the frame should be.

The dimensions of the frame should always be slightly larger than the print to allow for the expansion and contraction of the paper due to variations of humidity. If it is too tightly fitted, it will pucker if it expands. To allow for this movement, frames with the backing board held in place with sprung clips are preferable to those with a rigid system of wedges or paper tape. Backing card should always be acid free.

Screenprints should always be exhibited under glass. This will help to protect the paper from dirt, and to a small degree help to filter out ultraviolet light, which may bleach colors. The glass need not be thick: $\frac{1}{4}$in picture glass is adequate for prints up to 30×40in; for larger prints it is advisable to use antistatic plexiglass, since there is a risk that if the glass bends it may break and damage the print. There are two types of glass: picture glass, which is clear, and non-reflective glass, which has a slightly mottled surface that prevents reflections but slightly reduces the brilliance of the color of the image. If the print has been thoroughly dried, it will not be damaged by being in direct contact with the glass, so the question of whether or not to mount is basically an esthetic one.

Plain or decorated mats should complement rather than overpower the print; excessive use, or inappropriate use of decoration on a mat itself can reduce the impact of the printed image, making it secondary to the frame. It should also be noted that the color of the mat affects the color of the original print and that the size of the mat should not be so large as to dominate it. If mats are used, they should be made from acid-free mat board.

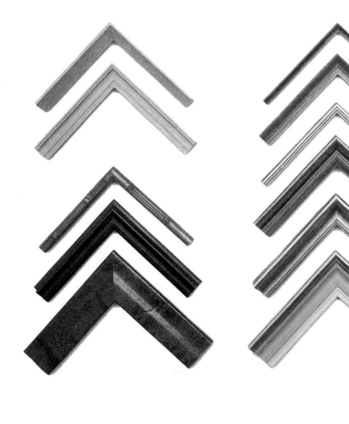

Types of moldings
There is a vast range of moldings available for frames. Among the most widely used are those made of metal or painted, stained or gilded wood. The choice is ultimately a matter of personal taste, but a successful framing solution is likely to be one in which the size, color and style of the molding is in keeping with the print it frames.

Mats for prints (above)

A delicate screenprint of Japanese people walking in a garden is shown with a variety of colored mats. It is interesting to note how these mats affect the impact of the print and the balance of color — the blue mat, for example, reinforces the blue so that it dominates the composition. The size of the mat here is not so large that it overpowers the print, but notice how the mat does not frame the print centrally. This takes account of the foreshortening that occcurs when the framed print is placed up on a wall.

Glossary

Autographic
An image made by hand rather than produced photographically.

BAT proof
BAT, standing for *bon à tirer*, literally, "good to print," is the phrase traditionally used by artists as an instruction to the printer to indicate that a proof is satisfactory and that all subsequent prints in the edition should be similar to it.

Bleeding
The seepage of excess ink through or under the stencil. This may occur when the ink is too thin for the mesh count, when the squeegee blade is blunt, when the printing angle is too low or when excessive pressure is used during printing.

Blending
A technique in which two or more colors are placed on the screen and the squeegee is used to combine them to produce a smooth transition of color before printing.

Bridging piece
Early stencils, as in packing case letters, used bridges to tie island areas, such as the middle of the letter "O," to the main body of the stencil. The use of a woven mesh to support the stencil in screenprinting has done away with the need for bridging pieces.

Drying in
The filling up of the open areas of a stencil when ink is allowed to dry into the mesh. This can occur for the following reasons: the ink is too thick; the mesh count is too fine; the conditions are too warm; printing has been interrupted or has taken place too slowly.

Edition
A set of similar prints from the same stencil(s). See also Limited edition.

Editioning
The printing of the required number of copies that make up the edition.

Filler
A viscous, often water-soluble liquid, used for sealing the stencil surrounds, stencil correction and repair, and to make hand-painted stencils directly on the mesh.

Flooding
Charging the screen with a thin layer of ink when it is raised above the printing surface. When the screen is lowered, the squeegee is used to press this thin layer of ink through the mesh on to the printing stock.

Frame
The rectangular wooden or metal structure over which the mesh is stretched to make a screen.

Half-tone
Like most other printing processes, screenprinting can produce only flat areas of tone or color. By photographing an image through a half-tone screen made up of a grid of lines, the continuous and variable tones of a wash drawing or photographic print can be turned into a matrix of black dots. The number of dots in a given area determines the lightness or darkness of the tones. This effect can readily be seen in the half-tones of newspaper photographs.

Lift off
Sometimes called "off contact" or "snap," this is the small gap between the print bed and the screen. The pressure of the squeegee brings the two into progressive contact, the mesh snapping away from the printing block in the wake of the squeegee.

Light fast
This term refers to the ability of pigments (used in printing ink) to withstand fading due to prolonged exposure to light.

Limited edition
An edition of prints limited to a specific number, each one signed and numbered by the artist. When a limited edition has been printed the stencils and positives are destroyed so that no further copies can be made.

Mesh
The woven fabric that is stretched across the frame to make the screen and to which the stencil is anchored.

Mesh count
The measure of the fineness or coarseness of the mesh, stated as the number of threads to the inch.

Mezzotint
A technique for approximating continuous tone similar to half-tone (above). The pattern of the grain in a mezzotint screen, however, is random instead of mechanically regular. (Not to be confused with the mezzotint that is a specific technique in intaglio printing.)

Monoprint
A one-off, unique, and therefore unrepeatable print.

Negative
An image that is in its tonal values the reverse of the positive original. In a photographic negative the dark areas of the subject appear light and the light areas are dark.

Open area
Any part of a stencil that allows ink to pass through the mesh. The term also refers to the space between the threads of the mesh, when it is expressed as a percentage of the total area.

Photopositive
A photographically-reproduced image printed on to transparent film from which a photostencil can be made.

Photostencil
A stencil made from light-sensitive material that has been exposed to ultraviolet light through a suitably opaque positive.

Posterization
A method of simulating continuous tone. The original is photographed several times with progressively varied exposures, each picking out a part of the tonal range. The greater the number of separate stages, the more effective the illusion.

Print
The product of the printing process —
in this context, usually an image on
paper.

Print bed
The surface of the press on which the
printing stock is placed.

Proof
A print taken at any stage of the
printing process to enable the artist or
printer to judge whether the effect is
as intended. See also Limited edition
and BAT proof.

Registration
The accurate imposition of each color
on top of previous colors, so that no
unintended overcuts or undercuts
occur to mar the final result.

Screen
The frame with the mesh stretched
over it on which the stencil is fixed.

Serigraph
A term used in the early days of
screenprinting to differentiate hand-
made fine art prints from their
commercial counterparts.

Shellac
A substance used as a waterproof
sealant over the frame and the joins
between frame and mesh after
applying gum strip. Polyurethane
varnish is an alternative.

Stretching
Attaching the mesh to the frame. This
can be done by hand, but for
professional work, use of a mechanical
stretcher that guarantees correct and
consistent tension is advisable.

Squeegee
The tool used to spread ink across the
screen and to press it through the
mesh in an even layer. It consists of a
blade set into a handle. There are
three types: hand, composite, and
one-arm.

Topside
The surface of the ink that holds the
ink and over which the squeegee is
pulled. The sides of the frame form a
well to contain the ink.

Tusche
A greasy lithographic ink used to
draw or paint directly on the screen to
create stencils by the gum and tusche
method.

Underside
The surface of the screen that is in
contact with the stock during printing
and to which the stencil is anchored.

Suppliers

The Advance Group
400 North Noble Street
Chicago, IL. 60622-6383

Advance-Excello inks for all materials. UV specialists, platen, cylinder and web presses. Full range of supplies, fabrics and screens.

Autotype USA
2050 Hammond Drive
Schaumburg, IL. 80173-3810

Photostencil films, emulsions, capillary, handcuts, masking film, diffusion transfer, preparation and cleaning chemicals, exposure calculator, signcutting films, swivel knife.

Avery/Fasson Speciality Div
250 Chester Street
PO Box 749
Painesville, OH. 44077

Pressure-sensitive base materials, cast and calendered vinyls, polyesters, solid foils, reflective and a variety of speciality films.

Cadillac Plastic and Chemical Co
530 Stephenson Highway
PO Box 7035
Troy, MI. 48007-7036

Source for quality film and sheet, stocked and converted locally across the US featuring lexan, mylaro, vinyls, acetate etc, sheets and rolls cut to press-ready sizes.

Cincinnati Ftg and Drying Sys
1111 Metz Drive
PO Box 37806
Cincinnati, OH. 45222-0805

Dryers, infra-red, gas, electric, exposure units, screen cleaners, hinge clamps, job boxes, catch pans, T-shirt printers, UV units, squeegees.

Colonial Printing Ink Corp
180 East Union Avenue
East Rutherford, NJ. 07073-9966

Screenprinting inks for textile, P-O-P, industrial PTF and conductive inks, UV curable applications, photo emulsions, screenmaking chemicals and supplies.

Ernst W Dorn Co Inc
15905 South Broadway Gardens
CA. 90248

Screenprinting supplies and equipment.

Mandel-Screentech Division
1319 N M L King Drive
PO Box 12124
Milwalkee, WI. 53212-0124

Four-colour process separations especially prepared for the screenprinting process. (large film blow-up to 50"×144").

Medalist M & M Research
1582 Harrison Street
PO Box 3008
Oshkosh, WI. 54903

Flat bed printers, automatic and semi-automatic, belt and wicket dryers, UV reactors, manual printers, circuit printers, squeegee sharpeners, auto-screen washers.

Monsanto Co
800 N Lindbergh Blvd
Saint Louis, MO. 63167

Fome cor, graphic arts board.

Naz-Dar/K C Coatings
1087 N North Branch Street
Chicago, IL. 50622-4292

Screenprinting inks, direct emulsions, screenfabrics, photoscreen film, school kits, frames, equipment, UV inks.

Nuarc Company Inc
5200 W Howard Street
Chicago IL. 80648-3404

Process cameras, screen exposure units, light tables, screenprinting equipment, vacuum frames, darkroom equipment.

SPE Incorporated
PO Box 2197
Huntington Beech, CA. 92647

Screenprinting and drying systems.

Sinclair and Valentine
201 East 16th Avenue
N Kansas City, MO. 54118

Conventional UV and waterbased screenprinting inks and coatings for paper, plastics, metals, glass.

Stretch Devices Inc
3401 North 1 Street
Philadelphia, PA. 19134

Newman roller frames, self-tensioning from 5" to 35".

Svecia USA Inc
220 Distribution Street
San Marcos, CA. 92058

Screen presses, UV, gas electric, IR dryers, stacking systems, washing, and stripping systems.

T W Graphics Group
722 E Simuson Avenue
City of Commerce, CA. 90040

Screenprinting inks, supplies and equipment.

Tekra Corporation
18700 W Lincoln Avenue
New Berlin, WI. 53151

Supplier-distributor/converter/coater of plastic film and sheeting, pressure-sensitive film, adhesive systems.

Tetko Inc
420 Saw Mill River Road
Elmsford, NY. 10523

Swiss precision woven stencil fabrics, wire cloth, chemical processing products, screenframes, screenmaking systems.

Ulano Corporation
255 Butler Street
Brooklyn, NY. 11217

Complete stencil systems — knife cut and photographic stencil film systems, direct emulsions, fabric and stencil prep, rubylith and amberlith brand masking films, CDF direct-film.

Union Ink Company Inc
452 Broad Avenue
Ridgerfield. NJ. 07067

Screenprinting inks for textiles, plastics, paper, metal, etc.

Index

Acknowlegments

The author and Quarto would like to thank the following for their kind permission to reproduce copyright material. We have credited the artist, publisher and the printer in that order. Where there is no printer credited the printer was Coriander Studios.

Abbreviations used: l=left, r=right, t=top & b=bottom

p2 Jack Miller/Christie's Contemporary Art & Coriander Studios; p9, Haruyo/Colonia Publications; p10 l Peter Blake/Metal Box; r Eduardo Paolozzi/Advance Graphics; p11 l Joe Tilson/Marlborough Gallery/Kelpra; r R B Kitaj/Marlborough Gallery/Kelpra; p12 Bruce McLean/Bernard Jacobson Gallery; p13 l Ilana Richardson/CCA; r Erté © Sevenarts Limited; p14 David Hockney, Parade 1981 © David Hockney 1981; p16, © Tom Phillips 1989, All Rights Reserved DACS; p17 l Erté c Sevenarts Limited & Kane Fine Art; r Brendan Neiland/Coriander Studios & Brendan Neiland/Anderson O'Day & Coriander Studios; p18 Lynx tee-shirts; p19 Laura Ashley Ltd; p22 Katherine Doyle/John Skzoke; p23 Peter Blake/Waddington Graphics/Kelpra; p33 Yuriko/Colonia Publications; p34 Raymond Spurrier; p37 Michael Potter/Michael Potter/Advanced Graphics; p49 Terry Wilson/Coriander Studios & Terry Wilson; p50 Allen Jones/Waddington Graphics/Kelpra; p51 Ben Johnson/Norman Foster; p52 Gerd Winner/Tate Gallery Print Collection/Kelpra; p53 t Wendy Taylor/Ionian Bank; b Andrew Holmes/Andrew Holmes; p67 Bianca Juarrez/Bianca Juarrez; p71 Anthony Benjamin/Sally Sarlott; p74 Anita Ford/Anita Ford/Anita Ford; p76 Sandra Blow/Quarto Publishing plc, Coriander Studios & Sandra Blow; p78 Henri Chopin/Henri Chopin; p79 Anita Ford/Anita Ford/Anita Ford; p80 Patrick Hughes/Coriander Studios & Patrick Hughes; p83 Patrick Hughes/Quarto Publishing plc, Coriander Studios & Patrick Hughes; p84 t Patrick Hughes/Thumb Gallery & Coriander Studios; b Duggie Fields/Coriander Studios & Duggie Fields; p85 Ray Wilson/Christie's Contemporary Art; p90 Michael Carlo/CCA Galleries/Michael Carlo; p86 Michael Carlo/CCA Galleries/Michael Carlo; p89 Bruce McLean/Quarto Publishing plc, Coriander Studios & Bruce McLean; p91 Anita Ford/Art for Offices; p95 Chloë Cheese/Quarto Publishing plc, Coriander Studios & Chloë Cheese; p96 Brad Faine/Christie's Contemporary Art; p97 Chloë Cheese/Thumb Gallery & Coriander Studios; p98 Norman Stevens/Coriander Studios; p101 Norman Stevens/Pirelli; p102 t Adrian George/CCA; b Tony Ansell/Marketing Week; p103 Andrew Holmes/Andrew Holmes; p104 t David Lewis/CCA; b Adrian George/CCA; p105 Reg Cartwright/Christie's Contemporary Art; p106 t Michael Heindorff/Bernard Jacobson Gallery; b Brad Faine/Christie's Contemporary Art; p107 Michael Heindorff/Bernard Jacobson Gallery; p108 t Norman Stevens/Coriander Studios & Christie's Contemporary Art; b Fraser Taylor/Business Art Gallery; p110/111 Ivor Abrahams/Bernard Jacobson & Coriander Studios; p112 Brendan Neiland/Thumb Gallery & Coriander Studios; p113 t Ben Johnson/Coriander Studios & Ben Johnson; b John Swanson/John Swanson; p114 Tim Mara/Tim Mara; p119 Ilana Richardson/Quarto Publishing plc, Coriander Studios & Ilana Richardson; p120 Ben Johnson/Peter Tonn; p121 Jack Miller/David Ringcroft, Coriander Studios & Jack Miller; p122 t Ben Johnson/Bernard Jacobson Gallery & Coriander Studios; b Harry Thubron/Coriander Studios; p123 Sylvia Edwards/CCA Galleries; p124 Jack Milroy/Jack Milroy; p125 t Jack Miller/CCA Galleries; b Boyd and Evans/Angela Flowers Gallery & Coriander Studios; p126 l Patrick Hughes/Paradox Publications; r Patrick Hughes/CCA Galleries; p127 Cozette de Charmoy/Editions Otizec; p129 Haruyo/Colonia Publications; p131 Chris Battye/Coriander Studios & Chris Battye; p135 Beryl Cook/London Contemporary Art/Advance Graphics.

The author would also like to thank the following for their help in the preparation of this book.

Ivor Abrahams, Daniel Bentley, Chris Betambeau (Advanced Graphics), Peter Blake, Sandra Blow, Nicholas Bravery, Clare Burton, David Case, Chloë Cheese, Mike Cole, Douglas Corker (Kelpra Studio), John Dimmock, Sylvia Edwards, Eric and Sal Estoric, Jerry Farrell, Stephanie Faine, Bob and Mary Fisher, Matthew Flowers, Georgina Hewitt, Phillip Gibbs, James Holden, Patrick Hughes, Tim Mara, Bruce McLean, John Parmenter, Chris Prater (Kelpra Studio), John Purcell, Ilana Richardson, Frankie Rossi, Tish Seligman, Raymond Spurrier, Jean Stevens, Nick Stuart, Tim Taylor, Lucinda Winstanley.